The

McKinley Monument

The

McKinley Monument

A Tribute to a Fallen President

Christopher Kenney

Charleston — London
History
PRESS

Published by The History Press
18 Percy Street
Charleston, SC 29403
866.223.5778
www.historypress.net

Cover image courtesy of the Wm. McKinley Presidential Library & Museum.

First published 2006

Manufactured in the United Kingdom

ISBN 1.59629.107.9

Library of Congress Cataloging-in-Publication Data

Kenney, Christopher.
The McKinley Monument : a tribute to a fallen president / Christopher Kenney.
 p. cm.
Includes bibliographical references and index.
ISBN 1-59629-107-9 (alk. paper)
1. McKinley National Memorial (Canton, Ohio) 2. Canton (Ohio)--Buildings,
structures, etc. 3. McKinley, William, 1843-1901--Monuments--Ohio--Canton.
4. McKinley, William, 1843-1901--Tomb. 5. McKinley, William,
1843-1901--Death and burial. I. Title.
F499.C2K56 2006
977.1'62--dc22

 2006002958

Contents

Acknowledgements

*T*his book is the culmination of a project that started in 2002 when the Canton Woman's Club asked me, as director of education of the Wm. McKinley Presidential Library & Museum, to present a program on the McKinley National Memorial. I started researching the history of the monument in the museum's Ramsayer Research Library and one thing led to another. Therefore I must give special thanks to the Canton Woman's Club for getting me started on this wonderful journey.

Thank you also to the board and staff of the Wm. McKinley Presidential Library & Museum (owned and operated by the Stark County Historical Society), especially Janet Metzger, librarian; Cindy Sober, Museum Shoppe manager; and Joyce Yut, director, for their support of this project. All historic images, unless otherwise noted, are from the collection of the Wm. McKinley Presidential Library & Museum.

I also extend my appreciation to the staff at Arnold Funeral Home who assisted me with the records surrounding William McKinley's interment at West Lawn and the subsequent movement of the family to the monument.

Most importantly I would like to thank my family: my father and mother, David and Jean, my grandfather George Cupernall and my grandmother Mildred Kenney for all their support throughout my life. Finally, my inspiration, my wife Kimberly; without her support, patience and encouragement I would not have been able to do this.

I dedicate this book to my two grandparents, Ralph Kenney and Mary Cupernall, who were never able to see me go into the history field.

Introduction

Thousands of loving hands have joined to bring the little family together in this beautiful temple.

—*William R. Day, September 30, 1907*

The McKinley National Memorial, a landmark in the city of Canton, Ohio, is the final resting place for the twenty-fifth president of the United States, William McKinley, his wife Ida, and their two daughters Katherine and Ida. Residents of Canton pass by the monument or run up and down the 108 steps everyday. As you are traveling on Interstate 77, the monument towers above the trees. But some may wonder, why is such a magnificent building in Canton? The answer is quite simple: William McKinley was and is Canton's favorite son. While the president was born in Niles, Ohio, he called Canton home. After his death, it was fitting that the president be laid to rest in the city where his career began, the place where he found his true love and ran for the highest office in the land.

The monument, as it is more commonly referred to, has stood as a lasting tribute to President McKinley for one hundred years. The organizations that have maintained this magnificent structure have faced many challenges over the last century, but have prevailed in preserving the monument for future generations.

As with any historic structure, historians always wish that the walls could talk. Hopefully this book will provide a voice for those walls, sharing the experiences that surrounded the monument throughout its years.

During his life William McKinley welcomed people to his front porch to speak with them and, more importantly, to listen to them. Through his monument he still welcomes visitors. So come in, look around and listen. You might just hear those walls talking!

1.

William McKinley

William McKinley, the man who would become the twenty-fifth president of the United States, was born in the small town of Niles, Ohio, on January 29, 1843. He was the seventh of nine children born to William McKinley Sr. and Nancy Allison McKinley. The family lived in a modest two-story frame house.

When William McKinley Jr. was nine years old, the family moved about ten miles away to Poland, Ohio, where the school system was much better. William McKinley Sr. wanted the best possible educational opportunities for his children. Young William attended the Poland Academy, and at seventeen went to Allegheny College in Meadville, Pennsylvania. He was only there a short time when financial and health problems forced him to leave college and return home to Poland. After returning to Poland, McKinley taught in a one-room schoolhouse for one term, earning twenty-five dollars per month. He also taught Sunday school, and in early 1861 became assistant postmaster.

When the Civil War broke out in 1861, McKinley decided to continue the family tradition of military service: both of his grandfathers had served in the War of 1812. In June of 1861, at the age of eighteen, he enlisted as a private in Company E of the Twenty-third Regiment of the Ohio Volunteer Infantry (OVI). He served under Rutherford B. Hayes, who would also become president of the United States. After McKinley's first taste of warfare he wrote in his diary, "It may be that I will never see the light of another day. Should this be my fate, I fall in a good cause and hope to fall in the arms of my Blessed Redeemer." McKinley served for all fours years of the Civil War and participated in some of

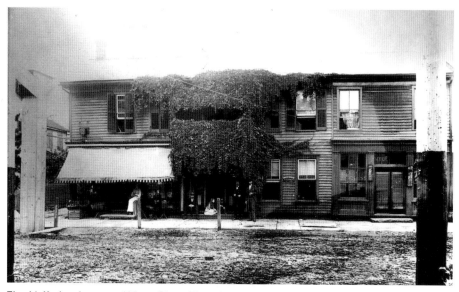

The McKinley home in Niles, Ohio. This photo was taken after the McKinleys moved to Poland, Ohio, and the home was converted into a store.

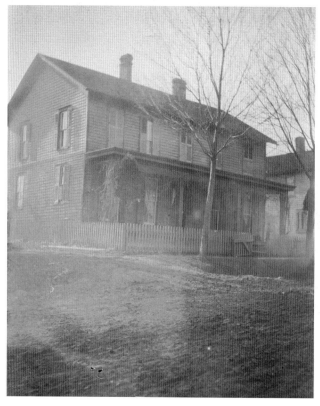

The McKinley home in Poland, Ohio.

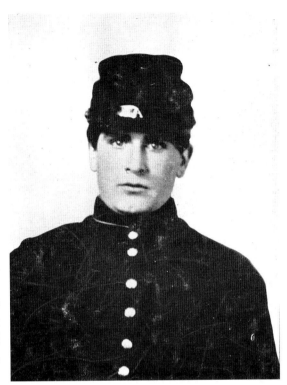

William McKinley in his private's uniform at the start of the Civil War in 1861. He was eighteen years old when he enlisted in the Twenty-third Ohio Volunteer Infantry.

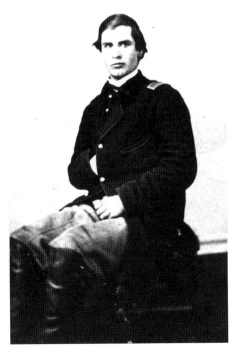

William McKinley at the close of the Civil War. By 1865, he had risen through the ranks and was discharged as a brevet major.

the fiercest battles, including South Mountain and Antietam. Miraculously, he was never wounded

McKinley was well liked by both the officers and the enlisted men in his company. As a result, he was promoted several times during his four-year military career. He earned the rank of commissary sergeant on April 15, 1862; lieutenant in September 1862; first lieutenant in February 1863; captain in July 1864; and finally major in March 1865. When the war ended he was discharged on July 26, 1865, with the rank of brevet major. For the rest of his life close friends and family would often refer to him as "the Major."

Following his military service, McKinley enrolled at the Albany Law School in 1865. He spent two years there and graduated in 1867, the same year that he was admitted to the Ohio Bar and moved to Canton. His sister Anna was already living in Canton and encouraged her brother to join her in the growing city, where there were many opportunities available for a young, energetic lawyer. Shortly after moving to Canton, McKinley formed a partnership—Belden & McKinley—with Judge George W. Belden.

Apart from his successful law career, William McKinley also became actively involved in local politics and community organizations, most notably the YMCA and the local Masonic Temple, which today is named for William McKinley.

Shortly after arriving in Canton, he caught the eye of young Ida Saxton, the belle of Canton. Her grandfather, John Saxton, was the founder of the local paper, *The Repository*, and her father James owned one of the local banks. It was in her father's bank that the two first met. They attended church and social functions together and eventually were married on January 25, 1871, in the newly constructed Presbyterian Church. The church was so new that a portion of it was not completed at the time. Over seven hundred guests attended the wedding, including then-governor of Ohio, Rutherford B. Hayes.

Almost a year later the McKinleys welcomed their first child, a daughter named Katherine, who was born on Christmas Day 1871. Two years later another daughter, Ida, was born. Sadly, neither of the little girls would survive. Baby Ida passed away on August 22, 1873, at four months and twenty-two days. Two years later on June 25, 1875, Katherine also died, six months shy of her fourth birthday. Katherine's death certificate listed heart failure as the cause of death. The two girls were buried in the family plot in West Lawn Cemetery. They would be moved to the memorial in 1907. Around the same time, Ida McKinley also suffered the loss of her grandfather, John Saxton, and her mother, with whom she was very close. All of these tragedies in such a short time span took a toll on Ida's health. She began suffering from various health problems, including seizures. These problems would plague her for the rest of her life.

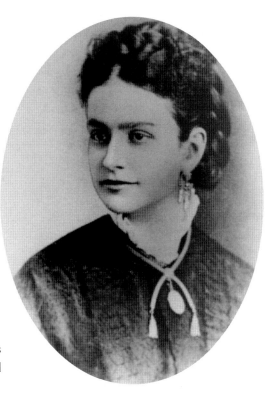

This photo of Ida Saxton was taken around the time she married William McKinley.

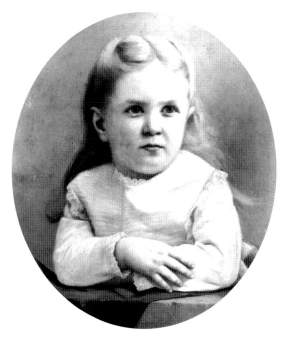

Katherine McKinley, born on Christmas Day of 1871, was the oldest daughter of William and Ida McKinley. She died on June 25, 1875. She is buried in the monument with her parents and younger sister Ida.

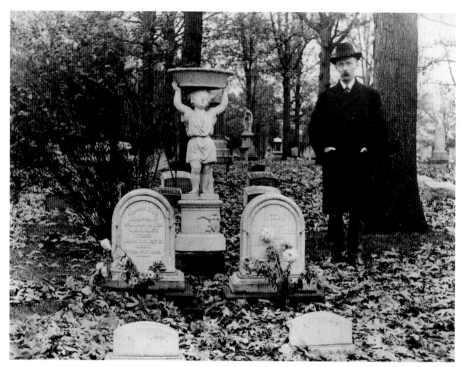

This picture taken in West Lawn Cemetery shows the headstones for Katherine and Baby Ida McKinley.

Despite personal tragedies, William McKinley's professional life flourished. He served as Stark County prosecutor, arguing cases in the same courthouse that still stands in downtown Canton today. He worked on Rutherford B. Hayes's campaign for governor, meeting many influential people along the way. When he was thirty-three, he ran for Congress in 1876. He based his platform on his belief in protective tariffs and sound money, two issues that continued to be driving forces throughout the rest of his political career. He won the election and spent the next fourteen years in Washington, serving the Forty-fifth through Fifty-first Congresses. He enjoyed tremendous success throughout his years in Congress and made many powerful friends who would help his career in the years to come. Although he became a strong leader for the Republican Party, he lost the 1890 re-election mainly due to redistricting and gerrymandering by the Democratic Party.

McKinley was not out of public politics for long. In 1891 he was encouraged to run for governor of Ohio, a position he held from 1892–96. In 1895 he accepted the Republican nomination for president. His opponent was William Jennings Bryan, a gifted speaker and campaigner who crisscrossed the country

gathering votes. Meanwhile, McKinley remained in Canton, and with the advice and guidance of Cleveland businessman Marcus Hanna, conducted one of the most successful "Front Porch" campaigns ever.

Thousands upon thousands of delegates arrived in Canton from all over the country. They would come into the train station located on Market Avenue South and literally form a parade that would march north on Market to the McKinley home. Hanna organized these delegations so McKinley knew exactly when each group was coming and what issues were important to them. Every delegation speaker was required to submit the text of his speech. As a result McKinley was able to tailor his speeches to the needs of each group. He greeted thousands from his front porch this way and made a point of shaking hands with everyone who made the trip. A newspaper reporter of the time, Murat Halstead, describes the experience of shaking McKinley's hand:

> *It allures the caller, holds him an instant, and then quietly and deliberately "shakes him." The hand goes out straight for you, there is a warm pressure of the palm, a quick drop, a jerk forward, and the thing*

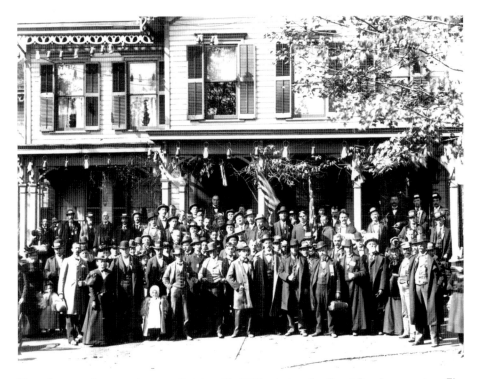

This photograph was taken on October 21, 1896, during the Front Porch campaign. The delegation is from Illinois.

is over. There is something besides the extended palm to allure you, and that is Mr. McKinley's beaming countenance. When greeting the public he never ceases to smile, it invites you forward and compels your own smile in spite of yourself.

McKinley ran on the same platform he used in his Congressional campaign—protective tariffs and sound money. He defeated Bryan and won the election of 1896. His first term in office was marked by several notable events including the death of his first vice president, Garret Hobart, from a heart attack; the Boxer Rebellion in China; and, of course, the Spanish-American War. McKinley led the country through these difficult moments and in 1900 the people elected him for a second term. He again defeated William Jennings Bryan, but this time by an even larger margin. President McKinley and his new vice president, Theodore Roosevelt, were now poised to lead the country into the twentieth century.

On Wednesday, September 4, 1901, just a few months into his second term, President and Mrs. McKinley left for the Pan-American exposition in Buffalo, New York. Thursday, September 5 was "President's Day" at the exposition and McKinley delivered what many thought was the greatest speech of his career. In this speech he made the famous quote that is now inscribed inside the McKinley National Memorial:

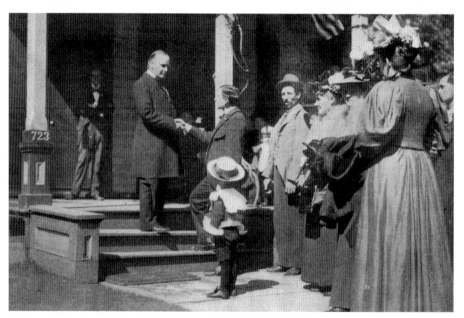

The caption on this photo reads "All the way from Cook County, Illinois, to shake the hand of our next President."

Let us ever remember that our interest is in concord, not conflict,
and that our real eminence rests in the victories of peace, not those of war.

The next day, September 6, President and Mrs. McKinley arrived on the grounds of the exposition at 3:30 p.m. Mrs. McKinley continued on by carriage to the Milburn home. President McKinley, accompanied by his secretary George Cortelyou and John G. Milburn, went to the Temple of Music. Security was heavy inside the temple, and all on guard were instructed to pay close attention to everyone who stood in line to meet the president. As was his habit, the president shook hands with everyone who passed by. Then, according to eyewitnesses, a man shook hands longer than many thought necessary. He drew attention to himself and guards quickly moved him along. During this commotion, however, they failed to notice the next man in line with a bandage around his hand. The man was Leon Czolgosz, an anarchist who viewed the office of presidency as a threat to the workingman. Czolgosz had been stalking

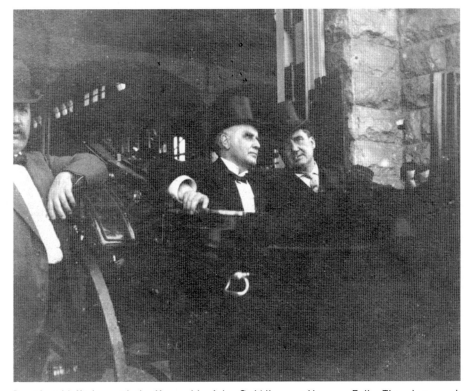

President McKinley with the Honorable John G. Milburn at Niagara Falls. This photograph was taken approximately one hour before the president was shot.

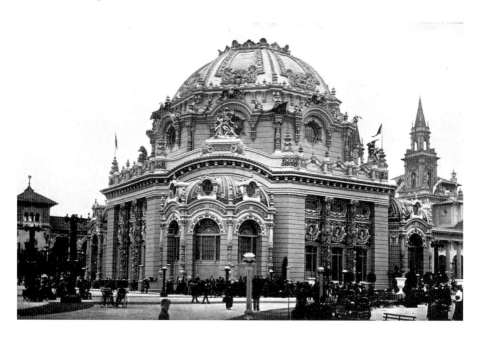

The Temple of Music in Buffalo, New York, had seating for 2,200 people. At the time it was built it contained one of the largest pipe organs ever built in the United States.

This photo shows the interior of the Temple of Music during the Pan-American Exposition held in Buffalo, New York. It was here that President McKinley was shot on September 6, 1901.

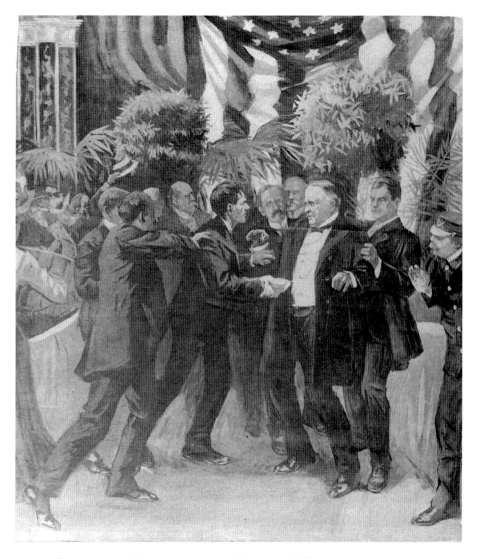

An artist's rendering of the assassination of President McKinley.

the president for some time, even following him to Meyers Lake in Canton. The bandage that was wrapped around Czolgosz's hand concealed a .32-caliber pistol. At 4:07 p.m., as President McKinley reached out to shake hands with Czolgosz, two shots were fired.

Security quickly jumped on Czolgosz and began hitting and kicking him. Reportedly McKinley urged them to stop, and not to hurt him. The president then said to his secretary George Cortelyou, "My wife—be careful, Cortelyou, how you tell her—oh be careful."

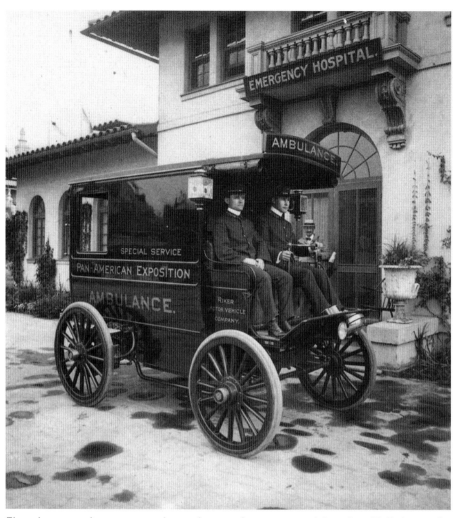

This electric ambuance is similar to the one that transported President McKinley to the hospital at the Pan-American Exposition following the shooting.

An electric ambulance arrived at the Temple of Music and rushed the president to an emergency hospital on the fairgrounds. Eleven minutes had passed since the two shots were fired. When doctors attended to the president they discovered he had been shot twice. The first bullet entered just to the right of the sternum and was easily removed. The second shot was far more serious, striking the president in the abdomen and piercing the stomach walls twice. Doctors tried in vain to locate the second bullet. The president's wounds were closed and he was taken to the Milburn home while he was still unconscious.

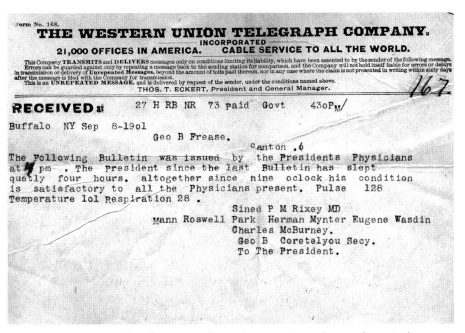

RECEIVED at 27 H RB NR 73 paid Govt 430P_M/

Buffalo NY Sep 8-1901
 Geo B Frease.
 Canton .6
The Following Bulletin was issued by the Presidents Physicians
at 4 pm . The president since the last Bulletin has slept
quetly four hours. altogether since nine oclock his condition
is satisfactory to all the Physicians present. Pulse 128
Temperature 101 Respiration 28 .
 Sined P M Rixey MD
 Mann Roswell Park Herman Mynter Eugene Wasdin
 Charles McBurney.
 Geo B Coretelyou Secy.
 To The President.

This telegram, received in Canton on September 8, 1901, indicates the president is in "Satisfactory Condition."

Vice President Theodore Roosevelt boarded a train in the Adirondack Mountains of New York to come to Buffalo. Early reports indicated that the president would make a full recovery, so Roosevelt returned to his vacation home. However, on Friday, September 13, 1901, McKinley's health took a turn for the worse. His wounds had developed gangrene. By Friday afternoon he called his surgeons to the bedside and told them, "It is useless, gentlemen. I think that we ought to have prayer." Mrs. McKinley was led to his bedside where he kissed her for a final time and said, "Goodbye—goodbye all, it is God's way. His will, not ours, be done." At 2:15 a.m. on Saturday, September 14, 1901, the twenty-fifth president of the United States was gone.

2.

The Funeral

*A*t the time of the president's death, members of his cabinet were staying at the Milburn residence in Buffalo. They immediately met to make arrangements for a proper funeral. On Sunday, September 15, one day after President McKinley's death, Theodore Roosevelt was sworn in as the next president of the United States in the Milburn residence. President Roosevelt and Ohio Governor George K. Nash set the funeral date for Thursday, September 19. There were very brief services for McKinley in Buffalo. The first was a private service in the Milburn residence for friends and officials by invitation only. Mrs. McKinley remained upstairs throughout this service but stayed close enough to hear what was going on. Following the service his body was moved to the Buffalo City Hall under military escort, where he lay in state from 1:30 p.m. to 11:00 p.m. An estimated one hundred thousand people passed through.

News of the president's death had reached Canton within minutes of his passing. *The Repository* ran a special edition bordered in black conveying the sad news. At 10:00 p.m. on the night of McKinley's death, Colonel Harry Frease received a call from Columbus advising him that the body would be arriving in Canton on Thursday, September 19. The body actually arrived on Wednesday, September 18, to give the residents of Canton more time to pay their respects. Mayor James Robertson headed a committee for the funeral service. Members of the executive committee included William R. Day, Henry W. Harter, William A. Lynch, F.E. Case and John C. Welty. Colonel Frease was instructed to act as quartermaster and find a place to house between six thousand and seven

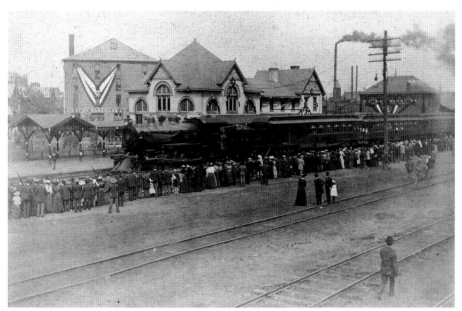

The funeral train carrying the body of President McKinley pulls into the Canton train station on Market Avenue on September 18, 1901.

thousand Ohio National Guard troops who would be sent to the city to provide security. The Methodist church held an informal memorial service attended by one thousand people. During this service Pastor Dr. C.E. Manchester and R.H. Cassidy, both close personal friends of McKinley, paid a touching tribute to him. The Sunday, September 15 edition of *The Repository* ran an editorial that read in part:

> *Unspeakable anguish on every face; eyes that tell of tears; hearts that throb as if to break; the rush of emotion that surges up in unbidden storm—evidences of these and myriad more, tell but little of the chilling grief that has the people in its cruel grasp.*
>
> *Memory is the dearest friend now. Bright and beautiful and inspiring, it glows with tenderest, [sic] dearest recollection of him for whom millions mourn, as man was never mourned by man.*
>
> *Husband, father, soldier, statesman, friend—none can too gloriously paint the picture for the wisest and best American manhood was typified in William McKinley.*

In this same edition stores omitted their usual advertising and bordered their ad in black and simply stated "In Memoriam."

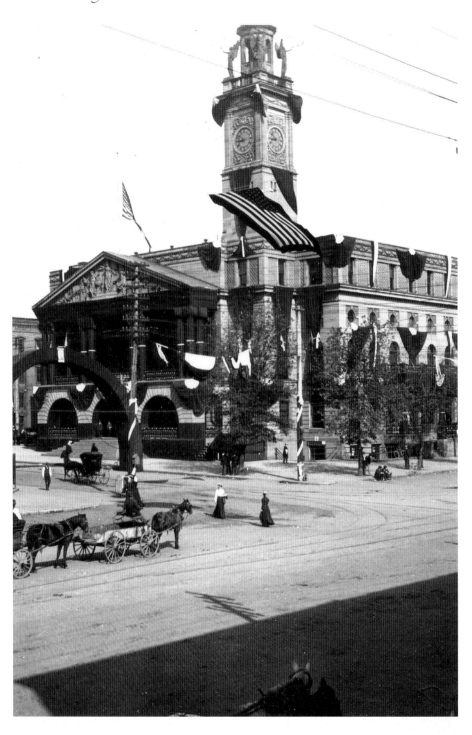

The Stark County Courthouse in downtown Canton is draped with black in a symbol of mourning for President McKinley.

The president's final trip to Canton began on Monday, September 16, when a special funeral train left Buffalo at 8:37 a.m. en route to Washington, D.C. The 420-mile trip was "a continuous pageant of mourning." At each city and town bands played and choirs sang *Nearer My God To Thee*, which had become known as the president's hymn.

On Tuesday, September 17, the citizens of Washington, D.C., had their opportunity to say goodbye to President McKinley. At 9:30 a.m. a funeral procession marched down Pennsylvania Avenue to the Capitol. Among those participating were President Roosevelt and former President Grover Cleveland. At 10:45 a.m. the casket entered the Capitol rotunda and shortly afterward the public was admitted. By 7:30 p.m., when the doors closed, an estimated sixty-five thousand people had filed past the casket. During this public viewing Mrs. McKinley remained at the White House. Finally at 7:30 p.m. the body was taken to the railroad station, and the train left for Canton at 8:10 p.m. All through the night the funeral train passed through small towns and villages, arriving in Canton at 11:08 a.m. on Wednesday, September 18.

A McCrea and Arnold hearse took the casket to the courthouse, passing fifty thousand people who lined the route. Along the way, the Grand Army Band played

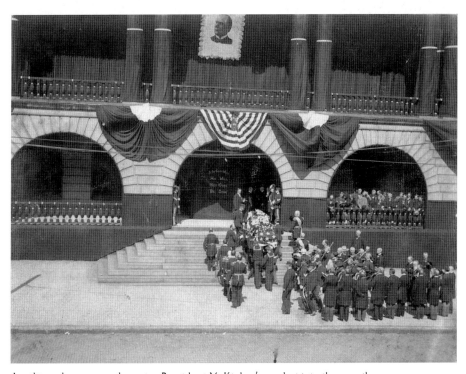

A military honor guard carries President McKinley's casket into the courthouse.

Nearer My God To Thee. Once at the courthouse, the Knights Templar provided guard duty as approximately thirty-five thousand people filed by between 1:15 p.m. and 6:00 p.m. When the doors to the courthouse closed, there were still thousands of people in line. The casket was then taken to the McKinley home on Market Avenue.

The morning of the funeral, Thursday, September 19, Mrs. McKinley spent a half hour alone with the casket. She would not attend the funeral services, instead staying at home for the rest of the day. The funeral procession started at the McKinley home at 1:14 p.m. and arrived at the First Methodist Church, now Church of the Saviour, at 1:30 p.m. Among the organizations that participated in the procession were: Canton Commandery No. 38 Knights Templar; The Grand Commandery Knights Templar of Ohio; The Knights Templar of Louisville, Kentucky and Pittsburgh; Eagle Lodge No. 431 (now the McKinley Lodge); The Grand Army Band; and Thayer's Military Band.

At the church, President Roosevelt occupied the front pew. Behind him were forty United States senators, one hundred and twenty representatives, and many state governors. Honorary pallbearers selected by the family included John C. Dueber, George B. Frease, R.A. Cassidy, William R. Day, Joseph Biechele, Henry W. Harter, William A. Lynch, and Thomas McCarty.

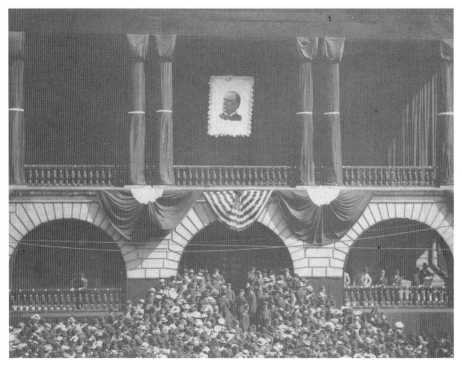

Mourners line up outside the courthouse to pay their final respects to Canton's favorite son.

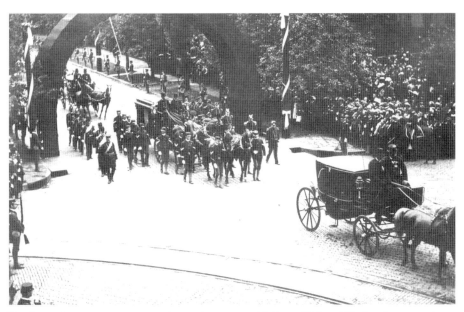

The funeral procession moving along what is now 6th Street NW and Market Avenue.

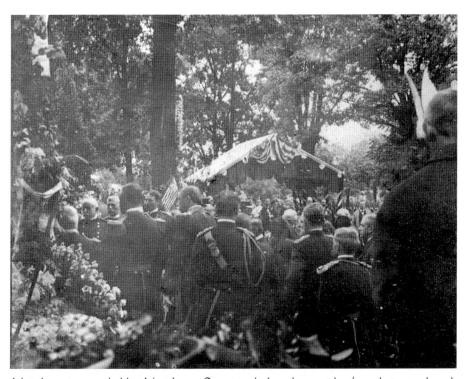

A brief service was held at West Lawn Cemetery before the president's casket was placed in the Werts Receiving Vault.

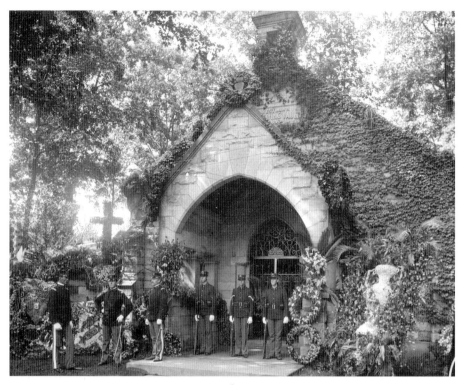

Soldiers stand guard over President McKinley's body at the Werts Receiving Vault.

The services ended at 3:30 p.m., and the procession re-formed and marched to the Werts Receiving Vault in West Lawn Cemetery. As the coffin was laid to rest, all economic activity on Wall Street came to a halt for a short time. Telephones and telegraphs fell silent. Streetcars and trains stopped, and workers paused for a moment of silence. Following a few final words, *Taps* was sounded, and the service closed with a selection by Thayer's Military Band and a song by the Knights Templar Male Chorus.

When all was done, the estimated one hundred thousand people who had come to Canton to pay their respects to President McKinley headed home, keeping the trains busy well into the night. So well-planned were the events surrounding the president's funeral that all who came found accommodations in what was a small city of only thirty thousand people.

Through all of this sadness, Mrs. McKinley amazed many with her courage and fortitude. Her work, and the work of many of President McKinley's closest friends and advisors, was not over. They were about to begin the daunting task of establishing a lasting memorial to our twenty-fifth president.

<div align="right">3.</div>

Design and Construction

*F*ollowing interment in the Werts Receiving Vault, William R. Day met with some of President McKinley's closest friends and advisors to discuss a final resting place and a suitable memorial. The group visited two possible sites and the decision for the current site was unanimous. Those taking part in the viewing and decision making were: Marcus Hanna, John G. Milburn, Cornelius N. Bliss, Alexander H. Revell, Henry C. Payne, William A. Lynch, Myron T. Herrick, Charles W. Fairbanks, William McConway, Frederic S. Hartzell and George Cortelyou. They chose a site McKinley had often visited when he was living in Canton. He admired the sweeping view and remarked that it would be a proper site for a monument—not for him, but for the soldiers and sailors from Stark County who had given their lives during times of war.

Those who took part in the site selection, along with several other representatives from throughout the United States, made up the first Board of Trustees of the McKinley National Memorial Association. President Roosevelt named the first Board of Trustees with input from Mrs. McKinley. Officers included: William R. Day, president; Marcus A. Hanna, vice president; Myron T. Herrick, treasurer; and Ryerson Ritchie, secretary.

The McKinley National Memorial Association was formally organized on September 26, 1901, "for the purpose of erecting and maintaining at Canton, Ohio, a suitable memorial to William McKinley; and for the raising of the necessary funds." The association informally decided that $600,000 was needed to construct and endow the memorial. So on October 10, 1901, they issued

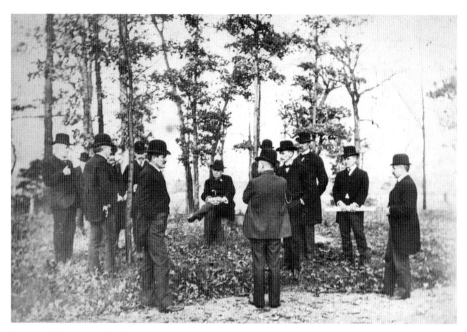

Some of the president's closest friends and advisors meet to discuss the location for a suitable memorial. From left to right are Cornelius Bliss, William A. Lynch, Henry C. Payne, Alexander Revell, Myron T. Herrick, Marcus Hanna (seated), William McConway, Charles W. Fairbanks, William R. Day, Frederic S. Hartzell and George B. Cortelyou.

This photograph shows monument hill from the east.

a public appeal for donations. The following month the group appointed an executive committee, and they held their first meeting in Cleveland on November 6, 1901. At this meeting it was decided the principal business office was to be in Canton, and Frederic S. Hartzell was put in charge.

The fundraising process was a national and international effort. Committees were set up in each state to coordinate the fundraising efforts. Each state in the union was assigned a monetary amount to collect determined by its population. The American Bankers Association designated all banks as donation sites, and all postal carriers were instructed to accept donations. To offset the cost of sending official telegraphs, Western Union and Postal Telegraph each credited the association $2,500. In Canton the association placed small metal banks throughout the community to collect spare change. Even schoolchildren were able to help! Governor George K. Nash proclaimed January 29, 1902, the anniversary of McKinley's birthday, a special day of observance for the state's schools. On this day, every schoolchild was given the opportunity to make a donation to the building fund. Soon donations began to pour in from across Ohio and the United States. Donors received

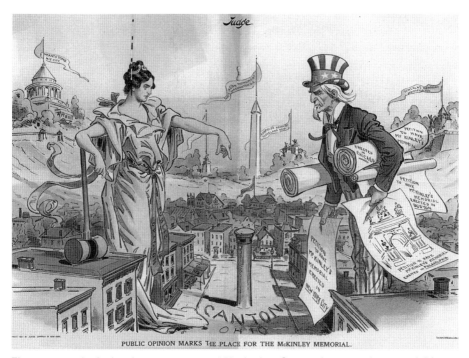

PUBLIC OPINION MARKS THE PLACE FOR THE McKINLEY MEMORIAL.

There was no doubt that the monument would be built in Canton; however there was lobbying to have the monument elsewhere. This cartoon appeared in the December 7, 1901 edition of *Judge Magazine* and illustrates that public opinion chose Canton, Ohio.

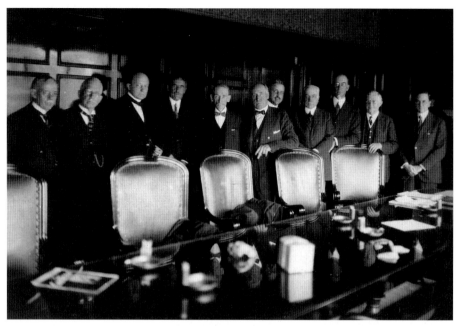

Members of the McKinley National Memorial Association pose for a photograph.

a certificate, signed by members of the association, stating that they had contributed to the construction efforts.

As donations started to add up, the McKinley National Memorial Association acquired the twenty-six acres around the site from West Lawn Cemetery and surrounding property owners. By June 1903 contributions reached $500,000. Although they wanted an additional $100,000 for an endowment, they finally had enough money to begin construction, so the association moved forward and announced on June 22, 1903, that they were accepting designs for the monument. In only six months, more than sixty designs had been submitted.

The trustees of the McKinley National Memorial Association consulted some of the foremost experts at the time, including architects Robert Peabody and Walter Cook, and sculptor Daniel Chester French, famous for his work on the Lincoln Memorial. This "jury of experts," as they were referred to, visited the site and then reviewed the designs. For their work each received $1,500. They invited the architects of the ten leading designs to submit plans no later than January 1, 1904. They were: E.P. Casey and Arthur Dillon; Guy Lowell; A.R. Ross; Arnold W. Brunner; Cass Gilbert; Careere & Hastings; Wyatt & Nolting; Eames & Young; D.H. Burnham; and Harold Van Buren Magonigle. Those architects whose designs were not chosen did not go away empty handed. Each was compensated $500 for their efforts.

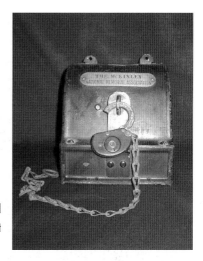

Small metal banks such as this one were placed throughout the community to collect change that went to the construction process.

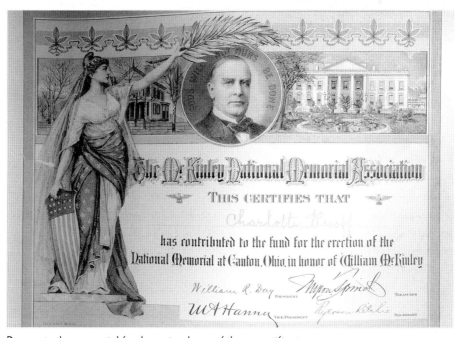

Donors to the memorial fund received one of these certificates.

The following series of illustrations and models show some of the designs that were under consideration. Where it is known, the architect or architectural firm is noted.

On November 22, 1904, the trustees met in New York and selected the design submitted by Harold Van Buren Magonigle of New York City. A portion of his

Arnold W. Brunner submitted this design idea.

Unknown architect.

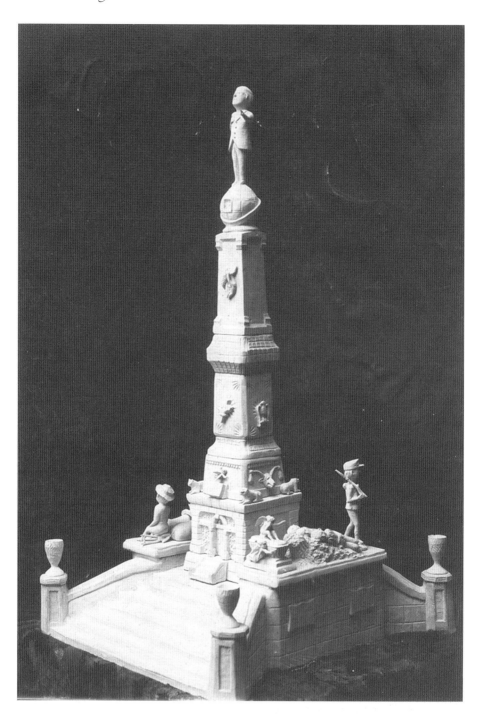

Unknown architect.

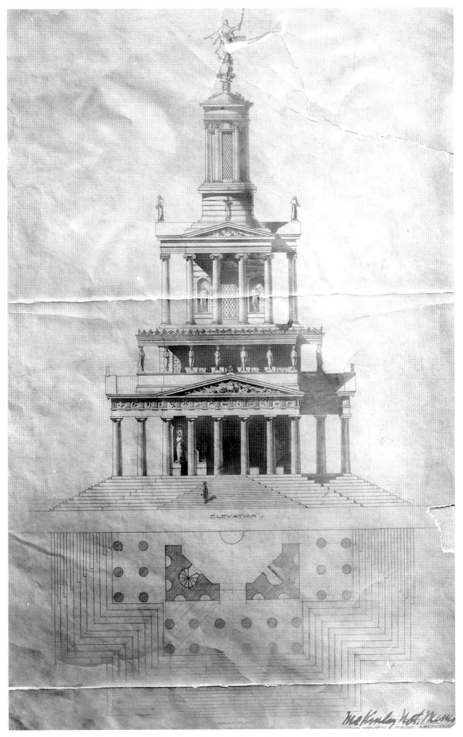

Harvey L. Page of San Antonio, Texas, submitted this plan for a multi-level memorial.

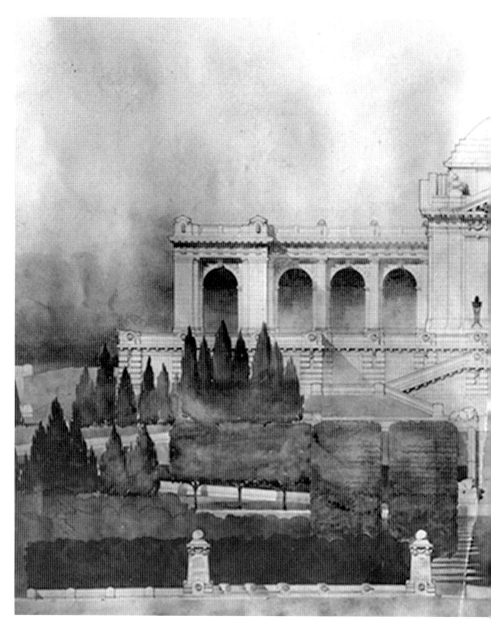

Casey and Dillon Design proposed this sprawling tribute for William McKinley.

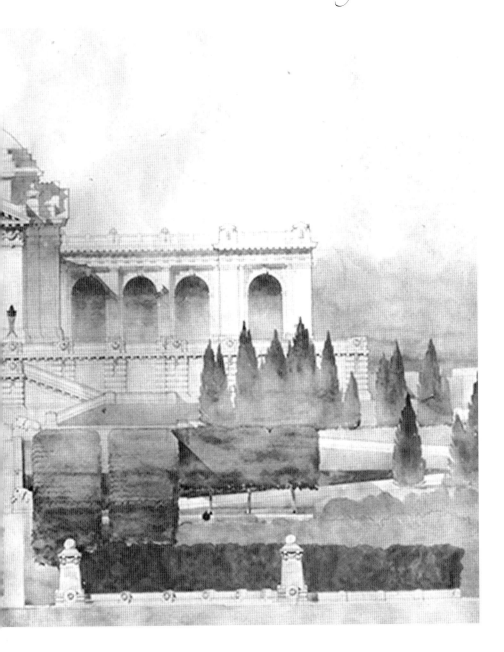

Unknown architect.

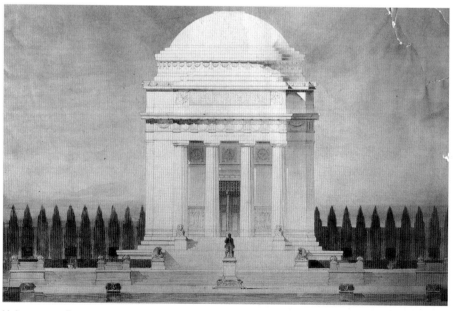

Unknown architect.

This design by Eames & Young of St. Louis also incorporates a domed structure.

FRONT ELEVATION SHOWING APPROACHE
MCKINLEY MEMORIAL CANTON OHI

Albert R. Ross's design is reminiscent of the Lincoln Memorial in Washington, D.C.

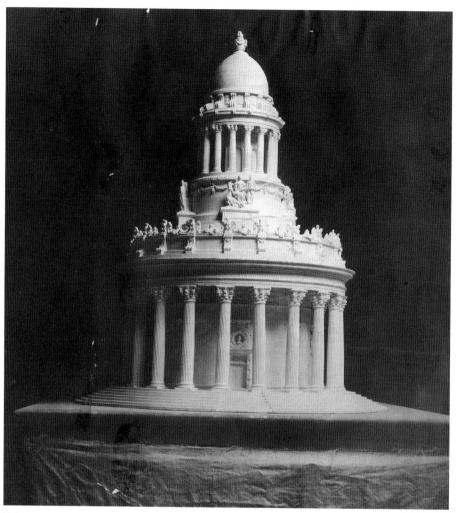

Unknown architect.

acceptance letter, written on October 20, 1904, by Frederic Hartzell, assistant secretary, reads as follows:

> *Designs having been received from all of the architects named, the Jury convened in New York City on this day, and, after due consideration, selected the design which you submitted, and I write, therefore, to inform you that you have been regularly appointed by the Committee on Design of the Association as the architect of the proposed memorial to William McKinley, under the conditions of the competition as originally presented to you.*

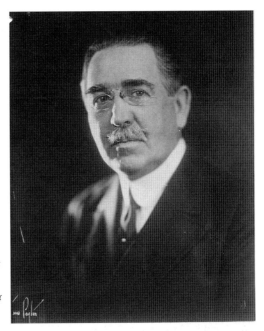

H. Van Buren Magonigle, ca. 1930. Portrait originally photographed by Strauss Peyton. *Courtesy Charles Scribner's Sons Art Reference Dept. records, [ca. 1865-1957], Archives of American Art, Smithsonian Institution.*

Harold Van Buren Magonigle was born in 1867 in Bergen Heights, New Jersey. He started practicing the art of architecture at the young age of thirteen when he worked as a draftsman for Vaux & Radford, the firm that designed Central Park in New York City. In 1887 he started working for McKim, Mead & White. While working there he received the Gold Medal of the Architectural League of New York.

After four years in New York he moved to Boston to work for Rotch & Tilden. In 1894, he received a fellowship to travel abroad and for the next two years studied and drew in Europe. He was the first student to enter the American Academy in Rome. Following military service in the Spanish-American War, during which William McKinley was president, he returned to his architectural work. He had two short-term partnerships before going out on his own in 1903, just one year before he won the competition for the McKinley National Memorial. Though the association rejected Magonigle's first design for the monument, an obelisk, they were obviously impressed with his work because they gave him a second chance.

Magonigle's work was varied throughout his career. Among his credits were the National Maine Monument in Central Park and the Firemen's Memorial in Riverside Park, both in New York City. In a letter to a potential client on December 26, 1918, he writes, "My practice has an extremely wide range—

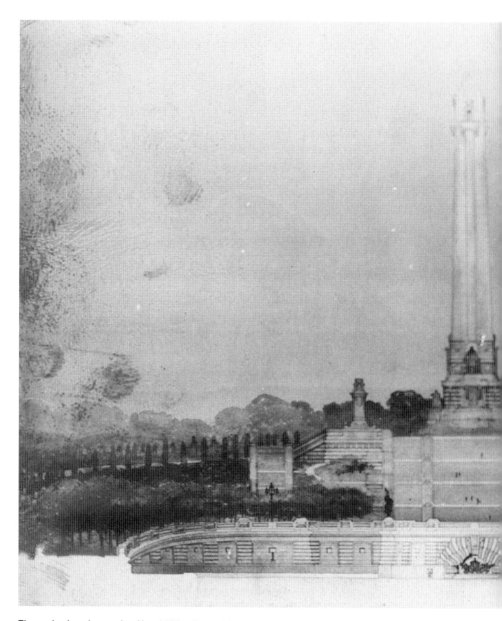

This is the first design that Harold Van Buren Magonigle proposed. *Courtesy Photography Collection, Miriam and Ira D. Wallach Division of Art, Prints and Photographs, The New York Public Library, Astor, Lenox and Tilden Foundations.*

from the national Memorial to President McKinley to a garbage incinerator plant in New York City." He worked internationally as well, spending months at a time abroad. In the mid-1920s he received a commission to build a new United States embassy and consulate buildings in Japan. He also won fourth place in a field of 137 people in the international competition for a plan for the federal capitol city of Australia.

Magonigle felt that an architect's designs should be kept closely guarded and not shared with other architects, especially if they were competing for the same project. An incident in the summer of 1921 clearly illustrates his feelings. The editor of *The American Architect* somehow acquired and published the designs of Magonigle and his rivals for the Nebraska capitol building competition. Magonigle wrote several letters to the editor criticizing his actions. Even after Magonigle's design was chosen, he still denied the editor permission to print the final plans.

Harold Van Buren Magonigle's talents were not limited to architectural design alone. He was a talented sculptor, artist and playwright. He also wrote extensively on art, architecture and architectural criticism. His wife Edith Marion Day was also an accomplished artist and collaborated with her husband on the Liberty Memorial in Kansas City, Missouri.

During his lifetime Magonigle received many honors. Among them was an honorary Doctorate of Architecture in 1931 from the University of Nebraska. He also served as president of the alumni association of the American Academy in Rome, and was an associate of the National Academy and a fellow of the American Institute of Architects. Magonigle had a long and successful career that ended with his death in 1935.

For the McKinley monument, Magonigle looked to the past for ideas. His design reflects the Greek revival or neo-Classical style of architecture common during the late nineteenth and early twentieth centuries. Inspiration for this design goes all the way back to the ancient world. Early cultures covered the bodies of their slain leaders with cone-shaped mounds of earth. Examples of such tombs include Caecilia Metella on the Appian Way and Hadrian's Tomb, now known as the Castle of San Angelo. Both of these sites are located in Rome, Italy. Over the years, these crude tombs improved out of necessity. As soil eroded away, stone walls were erected to keep the earth in place. As time went on, more importance was given to the architectural design of the walls. By the Byzantine Empire, domed tombs such as the tomb of Theodoric were being constructed. Magonigle wanted there to be no mistake that his design was a tomb, so he chose the dome design.

After examination of the site, Magonigle decided that the monument should be circular in shape to keep with the ancient influence and also to blend in with the natural shape of the land. The circular design also gave the

same perspective and proportions to the observer no matter what angle it was viewed from.

Magonigle envisioned the monument at the center of a large cross, representing the cross of a martyred president. The approach roads, Long Water and the main flight of stairs form the southern arm of the cross. Smaller flights of stairs create the eastern and western arms, and the northern arm is outlined by a straight driveway. That cross would also form the handle of a sword, symbolizing McKinley's military career and his role as commander-in-chief during the Spanish-American War. The blade of the sword was formed by what was called the Long Water, a 575-foot lagoon made up of five different levels, each twenty inches higher than the one before. The water cascaded down and ended in a reflecting pond, built by Ed Lander of Canton. (It was taken out in the 1950s due to poor circulation and was filled in and landscaped.) According to the architect's writings, his design considered these factors: the memorial was to be dedicated

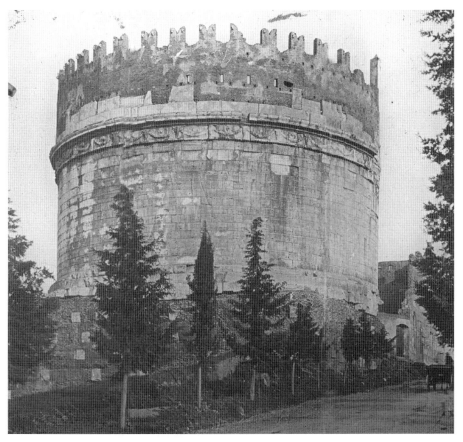

The Tomb of Caecilia Metella on the Appian Way in Rome, Italy. *Courtesy Bryn Mawr College.*

to a great man of simple and dignified life; it was to be erected in a small city, not a metropolitan center; and the funds were not such to warrant a lavish display, even if that had been appropriate, which it was not. In the most basic terms the design was a long vista between walls of foliage leading up to a green terraced hill crowned by the monument.

The monument is a double-wall and double-dome construction, meaning that there are two walls, interior and exterior, with a space in between and two domes, an outer dome and inner dome, also with an access space. For the construction of the dome Magonigle looked to the work of Rafael Guastavino, who perfected a method of using interlocking tiles and mortar to create self-supporting arch works. This distinctive style of architecture was used in many buildings including the Boston Public Library, Grand Central Terminal, Carnegie Hall, the U.S. Supreme Court building, the National Museum of Natural History, and Grant's tomb, which was dedicated on April 27, 1897, with ceremonies attended by President McKinley.

On May 31, 1905, two main contracts were made for the construction. The association contracted Harrison Granite Company of New York to erect the memorial at a cost of $257,600, and to construct the approaches for $109,462.

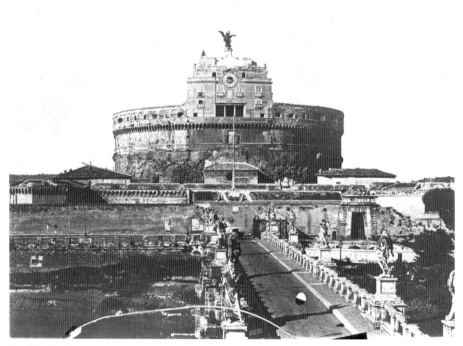

The Tomb of Hadrian in Rome, Italy. *Courtesy Bryn Mawr College.*

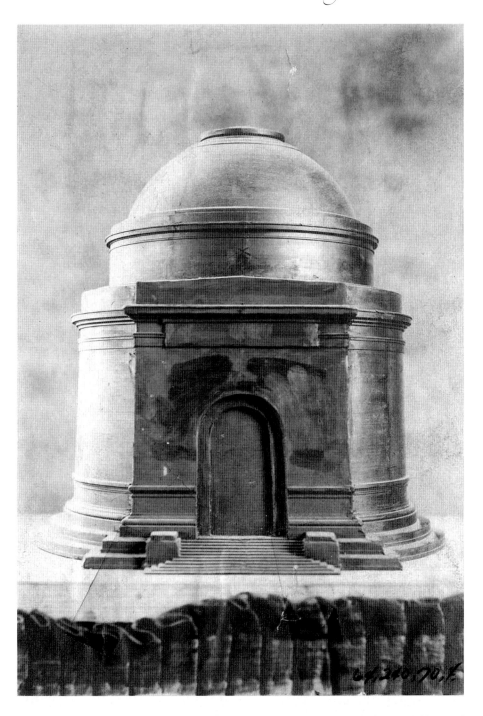

Magonigle presented this crude model of the monument to the McKinley National Memorial Association as part of the design process.

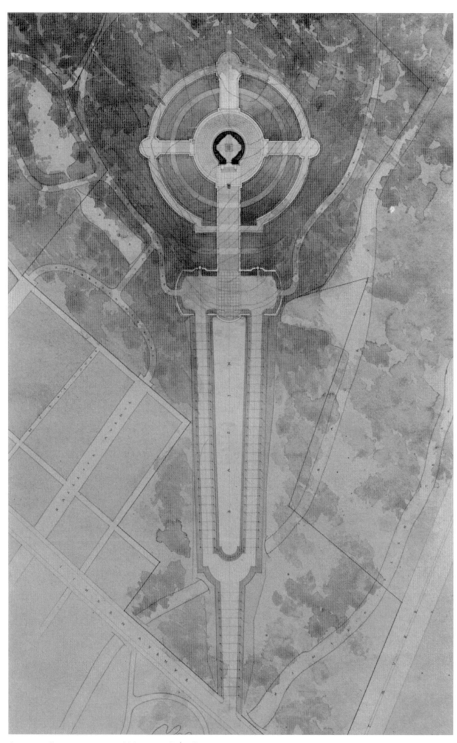

An aerial perspective of Magonigle's design.

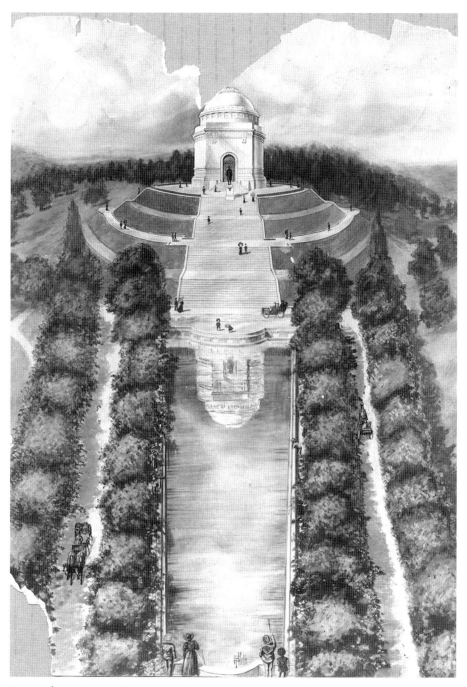

An artist's rendering of how the monument and grounds would appear.

The Harrison Company in turn subcontracted much of the work to George W. Maltby & Sons of Buffalo, New York. The Gorham Manufacturing Company of New York and Rhode Island fabricated the bronze work on the dome, doors and the interior for approximately $10,670. Several months later, on September 2, 1905, Charles Henry Niehaus entered into a contract to prepare models of the statue and lunettes, cast in bronze, and erect the statue. He also designed both the interior and exterior lunettes, costing the association $13,000.

On June 6, 1905, Magonigle removed the first shovelful of soil. Two weeks later work began on the approaches to the monument, and on July 20, 1905, excavation for the foundation began. The brick foundation walls are made up of more than two million bricks, all produced in Stark County. The brick walls are set fifteen feet deep on a double-ringed wall of concrete. By November 1905, the foundation walls were complete and the site was ready for the placement of the cornerstone. This ceremony took place on November 16 with Mrs. McKinley and other family members in attendance. William R. Day presided over the simple yet impressive ceremony. During the program a small copper casket containing material from McKinley's lifetime was placed in the cornerstone.

The construction process was truly a national and international effort. Nine states contributed material for the project, which arrived in Canton by rail and was then brought on horse-drawn wagons to the work site. Ohio supplied the concrete, all of the brick, and much of the labor force. Massachusetts provided the pink milford granite for the exterior. The interior marble walls, pedestal for the statue, and part of the marble floor came from the Grey Eagle quarries in Knoxville, Tennessee. Vermont provided the green granite for the double sarcophagus. The black granite base for the double sarcophagus and granite floor tiles came from Berlin, Wisconsin. Artisans in Illinois made the original skylight, though the current skylight was produced in Canton. All of the bronze work, including the large entrance doors, was cast in Rhode Island.

Workers for the project were from many nationalities and races. There is even an account of African Americans traveling from the Southeastern part of the United States all the way to Canton to ask for employment because of a deep admiration for President McKinley.

With construction of the monument well underway, attention turned to landscaping the grounds. In the fall of 1906, the McKinley National Memorial Association worked with George B. Sudworth, chief of the forestry division of the Department of Agriculture, to inspect the existing trees and make recommendations about the best variety of trees and plants to use. In February 1907, the association awarded the New York City landscape architectural firm of Wadley & Smythe the contract to do the work. Charles Anderson was appointed superintendent. That same month they began work by transplanting

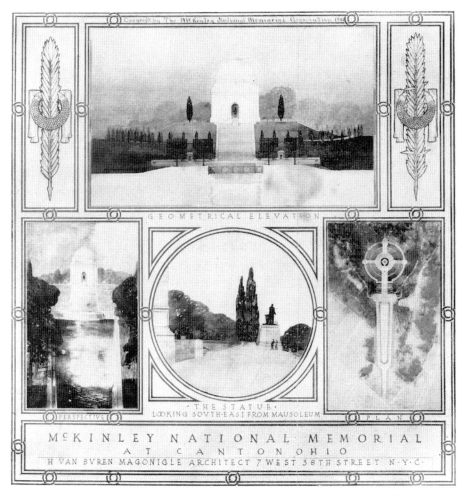

This montage of images was entitled "McKinley Memorial general views and details." It is believed that the association used these images for promotional purposes. *Courtesy Photography Collection, Miriam and Ira D. Wallach Division of Art, Prints and Photographs, The New York Public Library, Astor, Lenox and Tilden Foundations.*

forty-two full-sized maples and elms from nearby farms. An additional 350 large sugar maples, ranging from eighteen to twenty feet high, were planted along the entrance and elsewhere on the grounds. Planting was done with an eye to effective color schemes during the different seasons.

While construction on the monument went along largely on schedule, it was not without problems and delays. Weather posed the greatest problem, and there were several instances when work on the grounds had to be redone because rainstorms had washed out what had previously been finished.

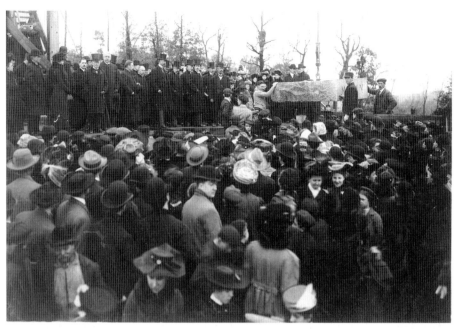

Mrs. McKinley and other family members attended the cornerstone-laying ceremony on November 16, 1905.

Mr. and Mrs. C.R. Woodard get a glimpse of the marble interior during construction.

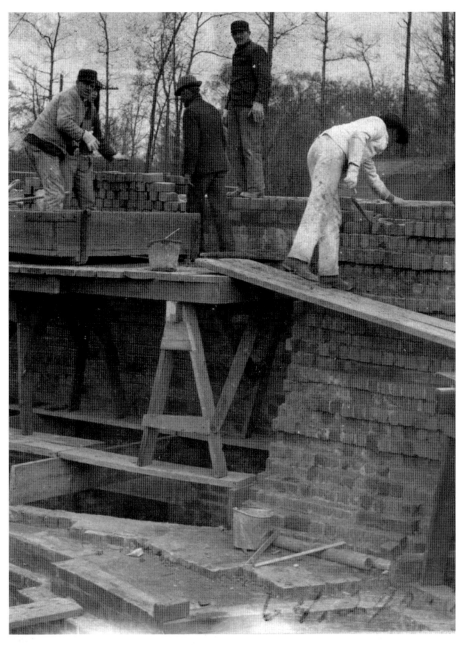

A bricklayer places one of the two million bricks that make up the foundation. Belden Brick and Metropolitan Block produced the majority of the bricks.

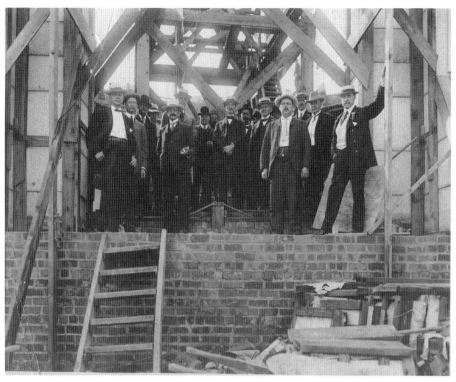

Workers pose for a photograph atop the completed basement of the monument.

This photo shows the early stages of construction looking from West Nimishillen Creek.

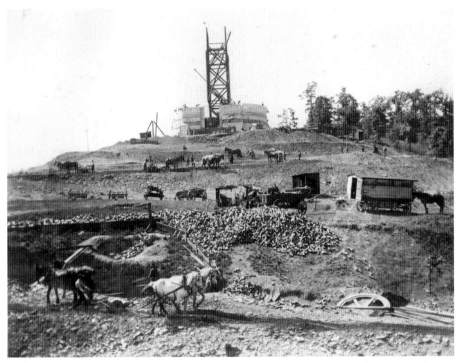

Workers using horse-drawn plows and wagons moved 35,000 cubic yards of soil to create the terraces. The caption on this photo reads, "Aug. 1906 the hill beginning to take on the form of terraces."

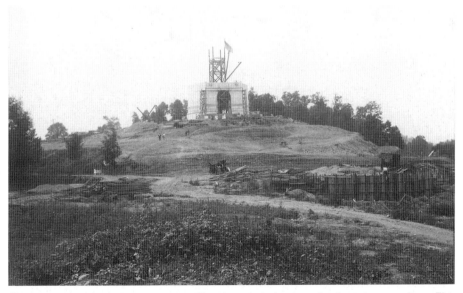

Construction on the monument was well underway before any landscaping was done. This photo shows the site before construction of the steps.

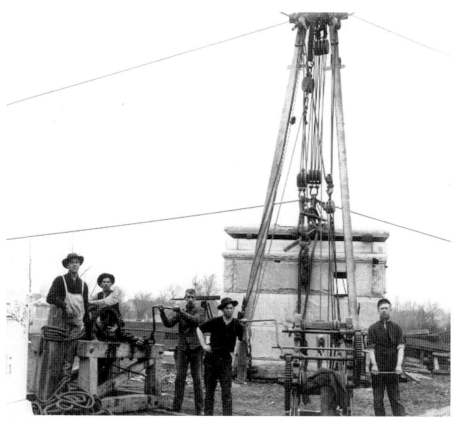

The lifting and setting of the granite blocks was accomplished almost entirely by hand-powered cranes using simple rope and pulley systems.

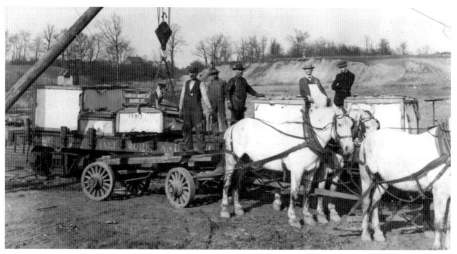

Horse- and mule-drawn wagons were used to transport material to the building site.

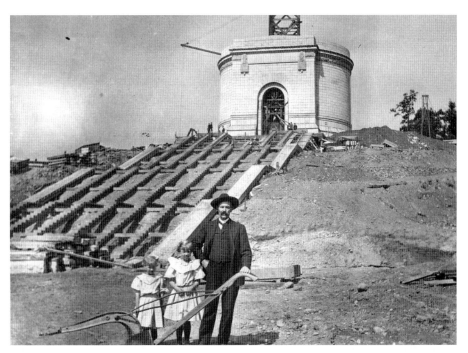

An unidentified man and two girls stand before the support structure for the 108 steps.

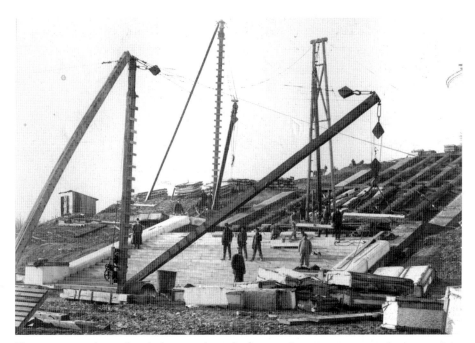

The caption on this undated photograph reads, "setting the granite steps and copings of the great southern approach."

The budget for the project also caused concern among the committee members. In a letter submitted by Magonigle for the September 17, 1907 meeting of the Board of Trustees he voices his concerns that the project may go over budget. He cites poor weather for increased labor expenses, as the workers had to repair storm damages. He also indicates that he instructed one-half of the workers to stop working until the financial crisis could be fixed. Magonigle does offer a solution to the money problems in this same letter. He and Frederick Smythe, the landscape architect, offered to give up a portion of their commission to get the project back on budget. The association took this under consideration, finally agreeing to pay the architects what they were owed, and to transfer money from the endowment to cover the deficit. Each member of the Board of Trustees was then charged with raising additional funds to replace the money borrowed from the endowment. This action highlights the frugal side of Magonigle. Later in his life he would write the following, "Failing information as to the reasons for this demand, I, as a prudent person, decline to pay you until you have proved to me that I owe it." This was in response to a second notice by the Internal Revenue Service in 1932 that he owed thirty-nine cents in unpaid income tax!

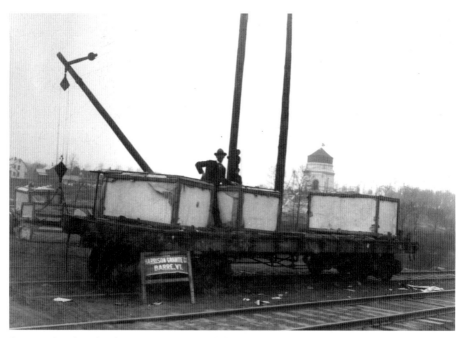

A special railroad siding was constructed for unloading material from rail cars. This car contains coping stones weighing sixteen tons each for use on the main staircase. The stones were then placed on horse-drawn wagons for transport to the building site.

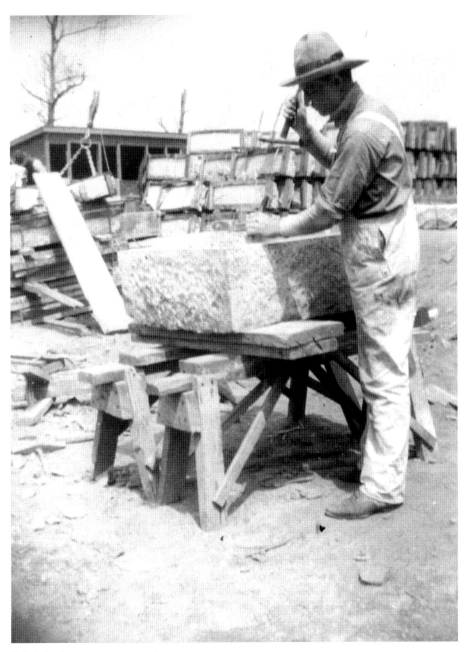

C.R. Woodard cuts a piece of granite.

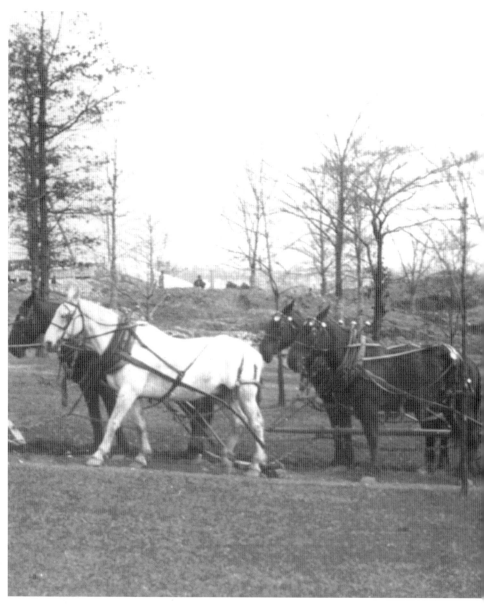

Members of the landscaping crew move a tree for replanting behind the memorial.

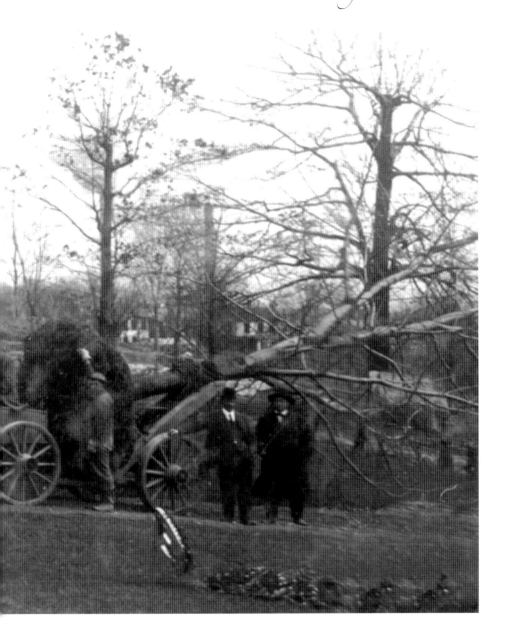

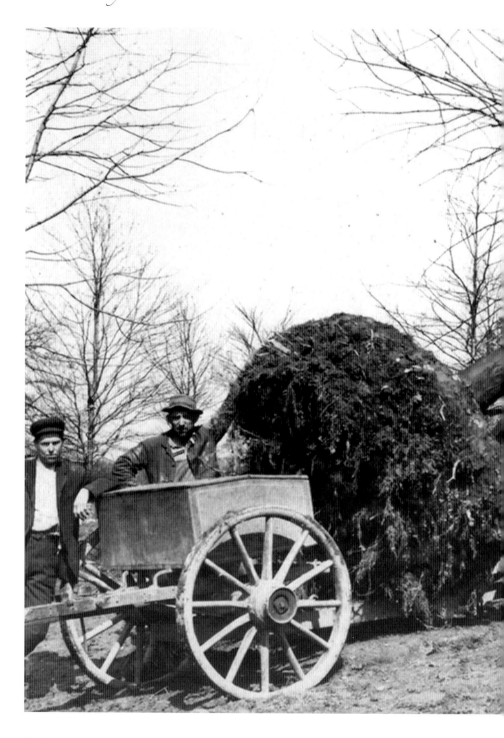

Each of the trees ranging from eighteen to twenty feet were moved one at a time on wagons such as this one.

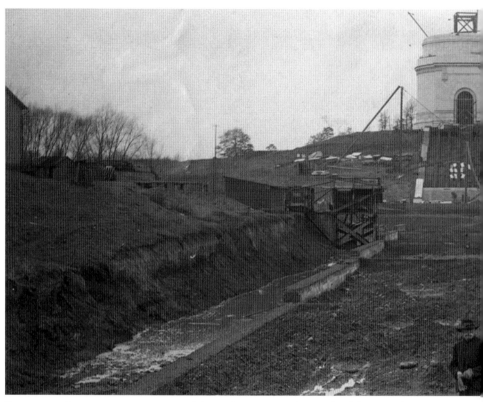

Progress on the monument continues while workers survey the needs of the Long Water.

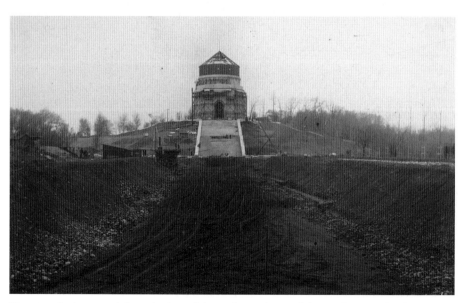

This view looking north from the Long Water shows the work being done on the dome.

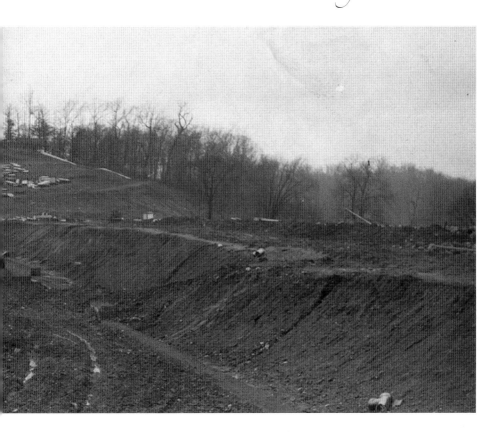

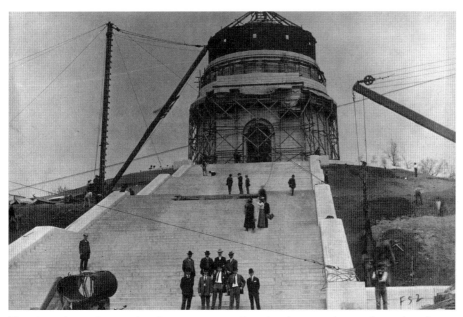

This photo shows the completed main staircase. Note that the statue has not been placed yet.

This chart shows the expenses associated with the construction process. The final figure does not take into effect the cost of the dedication ceremony or production of souvenirs.

Construction Costs:

Architect	$37,192.89
Books, Stationary and Printing	$29.14
Building	$394,021.27
Building—Sculptural	$13,000.00
Caretaker	$2.00
Chapman Plumbing & Supply Company	$150.00
Freight and Express	$8.64
Furniture and Fixtures	$439.40
Grading and Draining	$88,570.55
Insurance	$262.34
Labor	$267.33
Land	$28,396.01
Landscaping and Planting	$11,029.32
Lighting	$121.98
Livery Hire	$107.50
Material and Supplies	$150.66
Miscellaneous	$861.55
Miscellaneous—Plumbing	$353.70
Postage	$13.10
Superintendence and Inspection	$4,482.64
Telegraph and Telephone	$15.66
Traveling Expenses	$79.40
Water	$7,293.84
Total	$586,848.92

Source: The Transactions of the Board of Trustees: The McKinley National Memorial Association 1912–1916

L.J. Meyers of Canton is honored with the distinction of being the first official visitor to the monument. Meyers served as yardmaster for the

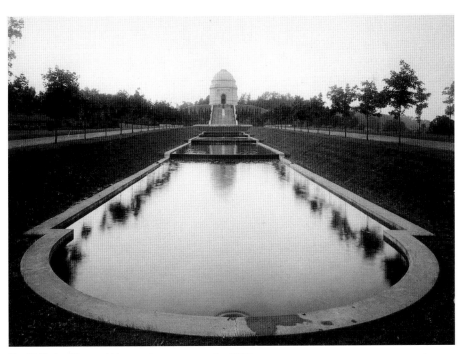

The McKinley National Memorial as it appeared in 1907.

Baltimore & Ohio Railroad during the construction. His job was to ensure that the material arriving by train was promptly sent to the construction site. His interest in the project earned him the respect and gratitude of Frank Maltby, construction contractor.

With the monument completed, Mr. Maltby informed Meyers that he wanted him to be the first visitor. Meyers, along with his wife Nettie Shafer Meyers and mother in law Mrs. Sarah Shafer, arrived around eleven o'clock on the night of completion. After a few final touches, the barricades were taken down and Meyers and his party entered the monument by torchlight. L.J. Meyers's grandson, William Betz, still resides in Canton.

On dedication day, the twenty-six acres surrounding the monument were meticulously finished. The manicured lawn, trees, and shrubs gave the impression of a long-established park, when in fact only six months had passed since the first tree was planted.

The design of the grounds and the monument are deeply symbolic. Each detail was carefully thought out and represents the character of President McKinley. It all tells a story—if you know where to look.

Architectural Details and Symbols

*E*ach detail incorporated into the monument was designed for a specific reason: to symbolically tell the visitor about William McKinley. We will begin at the bottom of the staircase and continue up to the top of the dome.

Visitors coming up the driveway will notice what many believe are guardhouses. Guards never used these two granite structures; instead, they were constructed for the storage of tools and other equipment for the maintenance of the grounds. From an aesthetic standpoint, they serve a dual purpose. First, they give points of interest at the ends of the driveways. Second, they act as part of a triangular composition along with the statue of President McKinley.

Aside from the monument itself, the next most impressive feature of the site is the 108 steps that make up the 194-foot main staircase. The staircase is constructed of granite and is arranged in four flights of twenty-four. Twelve more steps lead into the monument itself. Each granite tread is fifty feet wide. The original contours of the hill were changed by adding or moving thirty-five thousand cubic yards of soil to coincide with the height and pitch of the staircase.

Halfway up the main staircase stands a large bronze statue of President McKinley. The sculptor, Charles Henry Niehaus, was a native of Ohio, but was living in New York City. The statue is based on a photograph by Francis B. Johnston of the president giving his last speech in Buffalo shortly before he was shot. It is nine and a half feet tall and depicts President McKinley holding a manuscript of his speech. Behind him is a chair, symbolic of the chair of state, with a flag draped over it. The statue rests on a pedestal that is

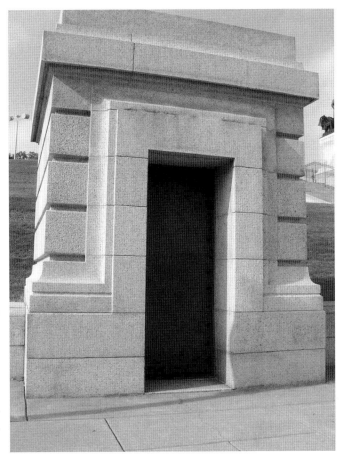

This building is one of two stone storage houses that flank the main staircase. Many refer to these as guardhouses; however, guards were never stationed in these structures.

thirteen and a half feet tall. John Lehman's *A Standard History of Stark County, Ohio* recorded a description of the pedestal by Magonigle. He writes:

> *The pedestal is extremely simple, the base being merely a torus, fillet and scotia, the die diminishing toward the top and having a slight entasis or outward curve. Near the top on each face are slightly sunken panels, with bands of oak leaves terminated with discs, in very low relief, set in them. Above the marble die is a moulded plinth of bronze with a delicate vine of conventionalized ivy running around it, signifying constancy, a distinguishing trait of the President's character.*

On the southern face of the pedestal are carved the words spoken by Benjamin Ide Wheeler, president of the University of California, when President McKinley was given an honorary doctorate of law. It reads:

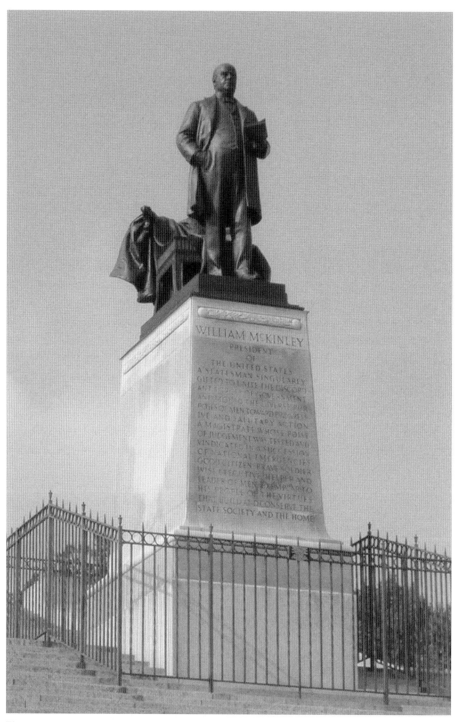

The bronze statue of President McKinley welcomes visitors as they make their way up to the monument.

WILLIAM MCKINLEY
PRESIDENT OF THE UNITED STATES

A Statesman singularly gifted to unite the discordant forces of government and mould the diverse purposes of men toward progressive and salutary action—a magistrate whose poise of judgment was tested and vindicated in a succession of national emergencies—good citizen—brave soldier—wise executive—helper and leader of men—exemplar to his people of the virtues that build and conserve the state, society, and the home.

On the northern side of the pedestal is inscribed, "This Memorial was erected by the contributions of more than one million men, women and children in the United States and many others in foreign lands."

There is an interesting point about the placement of the statue. According to Magonigle's original designs, the statue was to be placed at the top of the main flight of stairs. However, as stated in Volume III of *The Transactions of the Board of Trustees, The McKinley National Memorial Association,* the location of the statue was changed late in the process. The minutes report that on June 19, 1907, only three months before the dedication, Franklin Murphy, a member of the building committee, issued a report to the board which read, "At the suggestion of the Vice President [Charles W. Fairbanks], the statue has been transferred from the top of the main steps to the top of the second flight, vastly improving the whole composition."

At the top of the main staircase is a circular plaza that is seventy-five feet above the surrounding land and 178 feet in diameter. At this point visitors can examine some of the exterior details of the monument.

Architect Magonigle describes the monument as follows:

The mausoleum is a circular, domical structure of an exterior diameter of seventy-five feet above the base and ninety-seven feet high from the circular platform to the highest point, with a flat pavilion projecting slightly on the entrance or southerly side. It is without windows, [although today it does have lighting on the exterior and interior] and is lighted entirely through the oculus or opening in the dome. The exterior is treated with a strong water table and a band above it enriched with flat projecting panels. Over this rises a perfectly plain wall with an architrave frieze and cornice near the top. The frieze is decorated with heavy votive garlands of ivy much conventionalized, a version of the Greek treatment of the Hedera Helix. The only other decoration in this entablature is a line of strong dentils in the cornice. The entrance pavilion is approached by a short flight of steps leading to a lofty arched doorway set in an arched recess. The entablature of the

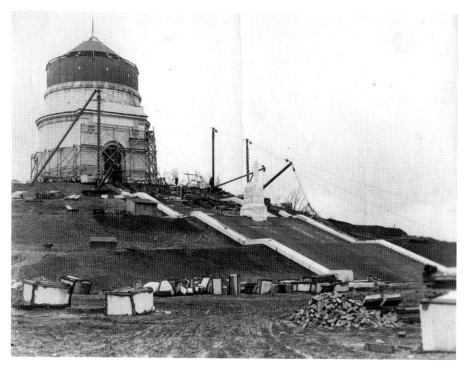

A muslin model of the statue was constructed so that it could be set in different locations on the steps to enable the association to decide where to place it.

circular portion of the building is carried across the pavilion, the architrave and frieze being interrupted over the doorway by a long panel, flanked at either end with a palm branch and wreath of immortelles. The panel bears this inscription in square-sunk letters:

1843 In Memoriam 1901
WILLIAM McKINLEY
President of the United States

The dome is topped by a civic crown and encircled near the top by a laurel wreath of gilded bronze. The frieze of the monument is decorated with ivy, again representing constancy.

Above the doorway to the entrance of the monument is an exterior lunette cast out of bronze by Charles Henry Niehaus, the same sculptor who made the statue of President McKinley. It represents the Victories of Peace. Mr. Magonigle describes the work as follows.

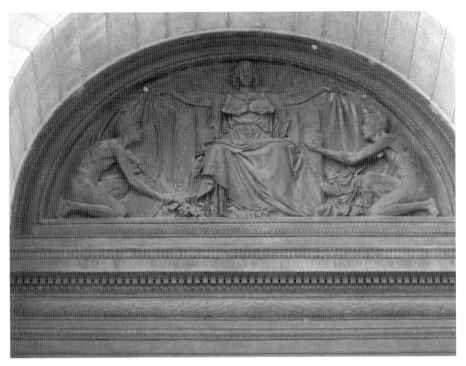

The bronze exterior lunette was designed by Charles Henry Niehaus and cast by the Gorham Company.

> *The Republic, typified by a seated female figure with the aegis on her breast,*
> *extends with both hands and ample cloak, expressing her protection of all*
> *that is worthy in her domain. On her right, War, personified by a youth,*
> *lays at her feet, his sword and shield wreathed about with laurel. On her*
> *left another youth submits the products of Industry. As a background a tree*
> *of laurel spreads its leaves, and in the whole composition the sculptor has*
> *sought to express the flowering and fruition of Peace.*

On the opposite side of the exterior lunette is the interior lunette. In her thesis entitled *The Classical Tradition and the Modern Memorial: The Work of H. Van Buren Magonigle*, Ruthanne Madway describes the lunette as follows: "The bas-relief sculpture in the interior lunette is emblematic of the power of the President both in peace and in war. It depicts the circular Presidential seal in the center placed above an upraised sword with the seal obscuring the blade. The sword is set within a crescent. To the immediate right and left are stylized fasces, symbolic of supreme power and authority; to the extreme right and left are cornucopia, emblematic of the abundance of peace."

A portion of one of the two bronze entrance doors, the largest bronze doors cast in the world at the time of installation.

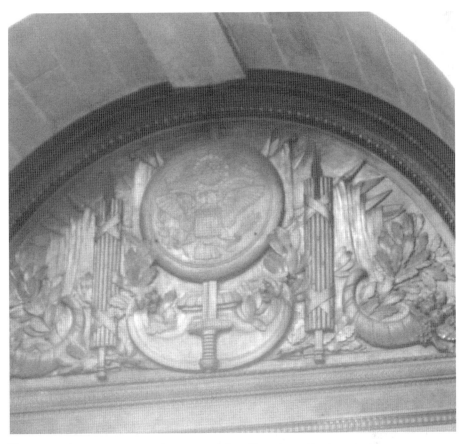

The interior lunette represents the power of the office of president.

The interior of the monument measures fifty feet in diameter and is seventy-seven feet from the floor to the top of the dome. The interior is constructed entirely from marble quarried from the Grey Eagle quarries in Knoxville, Tennessee. It is the focal point of the whole design. The floor is constructed of different colored marble forming a Greek cross. The arms of the cross extend into four arched recesses or "bays," and the base of the double sarcophagus is at the heart of the cross.

In the center of the monument rests the double sarcophagus carved from dark green granite from Windsor, Vermont. Each one is carved from a single block but designed to appear as two-in-one. It rests on a base of "Black Berlin" granite from Wisconsin. There are lions' heads carved into the four corners of the base. Around the top of the sarcophagus is a band of gilded laurel. This wreath symbolizes the triumph of love over death. On the sides are large rings cut out of solid granite. On the ends closest the doors are gold-plated bronze letters with the simple names: William McKinley, Ida McKinley.

There are four recessed arches or "bays" in the interior of the monument. Doric columns measuring three feet in diameter flank the arched recesses. Over each arch are keystones bearing thirteen stripes representing the thirteen stripes on the American flag.

Mr. and Mrs. C.R. Woodard pose with the model for the eagles that grace the interior of the monument.

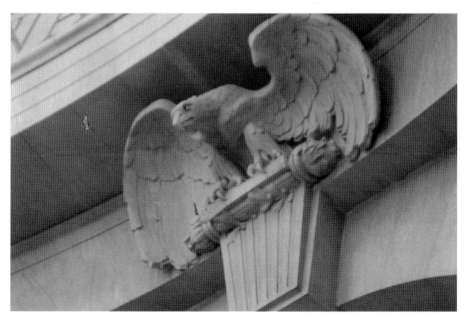

Perched on the four arches are sculpted eagles with wings partially outstretched, ready to take flight. They are holding in their talons a thunderbolt wrapped in olive branches. The position of the eagles gives them the appearance that they are watching over and protecting the president and his family.

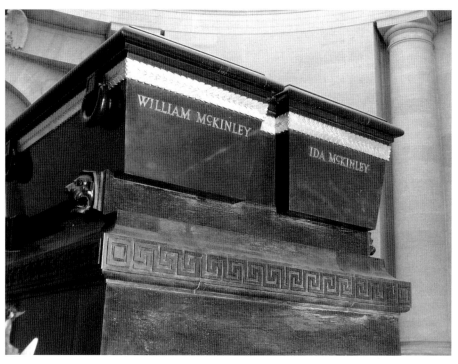

The double sarcophagus contains the bodies of William and Ida McKinley.

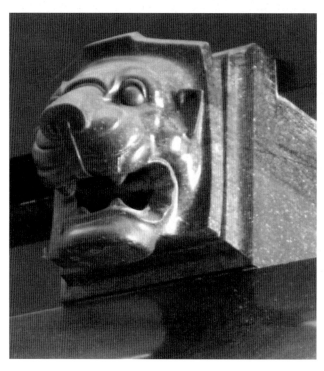

One of four lion's heads located on the corners of the double sarcophagus's base.

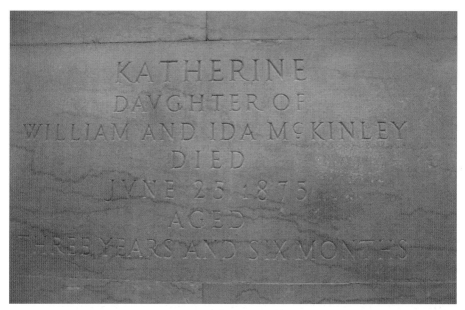

The headstone for Katherine McKinley is located in the northern wall of the monument. It reads "Katherine Daughter of William and Ida McKinley Died June 25, 1875 Aged Three Years and Six Months."

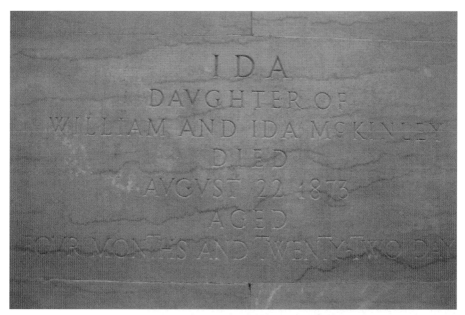

The headstone for Ida McKinley, located next to her sister, Katherine. It reads, "Ida Daughter of William and Ida McKinley Died August 22, 1873 Aged Four Months and Twenty-Two Days."

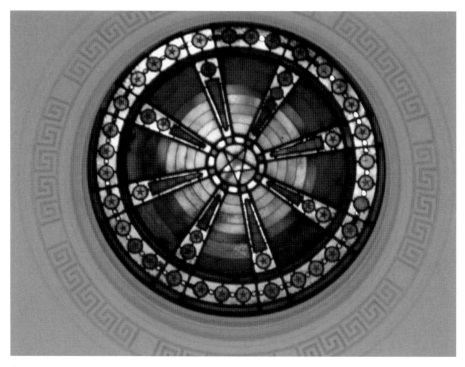

Over seventy feet above the floor is a red, white and blue stained glass skylight. It measures twelve feet in diameter and has forty-five stars in the design, representing the forty-five states that were in the United States at the time of the president's death.

An unusual aspect of the monument is the placement of the double sarcophagus. Unlike the tombs of Napoleon and Grant, where the sarcophagus rests in a crypt and is seen from above, the double sarcophagus for President and Mrs. McKinley is raised. According to the architect, "it would be far more dignified and impressive to raise the double sarcophagus above the mortuary chamber floor so that visitors should lift their eyes to the illustrious dead."

Directly behind the double sarcophagus, in the northern recessed arch, are entombed the bodies of the McKinleys' two young daughters, Katherine and Ida. A small concrete floor was installed between the inner and outer walls of the monument to support the children's caskets.

Looking up to the top of the dome one will see a magnificent red, white and blue stained glass skylight. It has forty-five stars in it representing the forty-five states that were in the Union at the time of the president's death. While it was part of the original design, the skylight, for unknown reasons, was never installed. White Associates, a Canton glass company, constructed the current skylight using

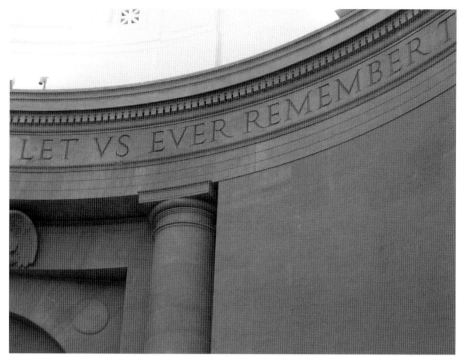

The words begin a quote that encircles the interior base of the dome. The quotation is from the president's last speech, just prior to his assassination.

the original designs. It was installed during a restoration project that coincided with the bicentennial celebration of the United States in 1976.

Around the base of the dome is a quotation from the last speech that President McKinley ever gave. It gives a profound insight into the type of person he was and the strong convictions that he lived by. It reads, "Let us ever remember that our interest is in concord, not conflict, and that our real eminence rests in the victories of peace, not those of war."

Magonigle carefully thought out each element of the design as he created a lasting memorial suitable for William McKinley the man and William McKinley the president of the United States. With all the details in place, the McKinley monument was ready for dedication.

5.

The Dedication

\mathcal{T}he dedication of the McKinley National Memorial was one of the greatest occasions in Canton's history, next to the Front Porch campaign of course. The event took almost a year in planning and preparation. On October 4, 1906, the trustees of the McKinley National Memorial Association met and decided the ceremony would take place on September 30, 1907. William R. Day, as president of the association, appointed the following for the dedication committee: William McConway, Charles W. Fairbanks, William A. Lynch, Charles G. Davies, George B. Cortelyou and Myron T. Herrick. President Roosevelt was secured as the primary speaker for the day. The mayor of Canton, Arthur Turnbull, also appointed a committee of citizens to assist with the event.

On the day of the dedication President Roosevelt and his party arrived at 10:00 a.m. They were escorted to Public Square by many of the same mounted escorts that had participated in the Front Porch campaign and McKinley's funeral. The journey to Public Square was routed past Central High School, on the corner of McKinley Avenue and Tuscarawas, the present day location of Timken High School. At the school fifteen hundred students dressed in red, white and blue formed a huge American flag. As President Roosevelt got closer to the students they began singing the national anthem.

The dedication parade began at McKinley's home at 10:45 a.m. and headed south on Market Avenue, past the reviewing stand, out to the monument, and then back to the reviewing stand, which was large enough to accommodate one thousand people. It was here that President Roosevelt, Ohio Governor Andrew Harris, Canton's Mayor Turnbull, the McKinley National Memorial Association

trustees, and other special guests watched thousands march past. The first units of the parade reached the reviewing stand at 11 a.m. Among those marching were Fiala's Military Band, Massillon City Band, Thayer's Fifth Regiment Band, Canton's Grand Army Band, the Marine Band, and other bands from as far away as Pittsburgh and Chicago. The Knights Templar, Knights of Pythias, Patriarchs Militant, and the Junior Order of the United American Mechanics also made up the ranks.

At noon President Roosevelt and members of the McKinley National Memorial Association went to the Canton Auditorium for a luncheon. Meanwhile, crowds that had viewed the parade headed to Monument Hill, or "God's Acre" as it was referred to in *The Repository* on that day. At 2:00 p.m. President Roosevelt and the association members arrived and the ceremony began with William R. Day as master of ceremonies. Day addressed the crowd and reviewed the progress of the memorial from McKinley's funeral up to that moment. He reported that $578,000 had been raised, coming from more than one million contributors. The association had spent $541,000 on the project with $37,000 reserved for an endowment.

John Lehman, author of *A Standard History of Stark County, Ohio* describes what happened next.

> At the conclusion of [Judge] Day's address, Governor Harris announced the unveiling of the statue that stood, draped in flags, overlooking the great audience. Miss Helen McKinley, the President's sister, was led to the center of the platform by [Judge] Day, and a garland of flowers was placed in her hand, attached to which was a line that connected with the beautiful canopy of the statue. With an obeisance full of dignity and pathos she drew the slender cord, the flags parted, and the bronze figure of her sainted brother was disclosed. The hush that covered the splendid gathering for a brief period while the banners gracefully parted and receded from the wonderfully lifelike work of the sculptor, was a touching tribute of regretful homage by a people instinct with patriotic devotion.

Following the unveiling of the statue, Governor Harris introduced poet James Whitcomb Riley who read the following poem he had written especially for the occasion:

> He said: "It is God's way:
> His will, not ours be done."
> And o'er our land a shadow lay
> That darkened all the sun.
> The voice of jubilee
> That gladdened all the air,

The Trustees of
The McKinley National Memorial Association
request the honor of
your presence at the ceremonies attending the dedication
of the monument erected in memory of
William McKinley
at one o'clock, on Monday, the thirtieth of September
One thousand, nine hundred and seven
at Canton, Ohio

The oration will be delivered by
Theodore Roosevelt
President of the United States

This two-page invitation (above and opposite) requests the honor of your presence for the dedication of the McKinley monument.

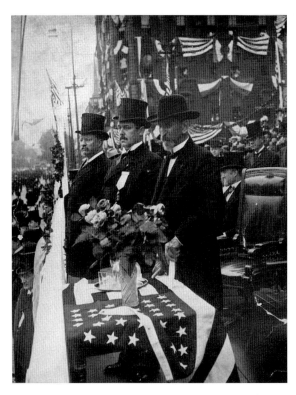

From left to right: President Theodore Roosevelt, Canton Mayor A.R. Turnbull and Ohio Governor Andrew Harris watch the dedication parade from the president's reviewing stand.

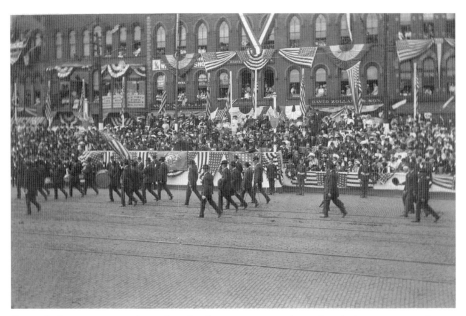

One of the many marching bands that participated in the dedication parade on September 30, 1907.

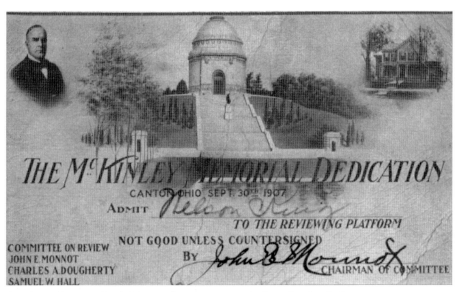

A ticket admitting the holder to the reviewing platform for the dedication ceremony.

Fell sudden to a quavering key
Of suppliance and prayer.
He was our chief—our guide—
Sprung of our common Earth,
From youth's long struggle proved and tried
To manhood's highest worth:
Through toil, he knew all needs
Of all his toiling kind—
The favored striver who succeeds—
The one who falls behind.
The boy's young faith he still
Retained through years mature—
The faith to labor, hand and will,
Nor doubt the harvest sure—
The harvest of man's love—
A nation's joy that swells
To heights of Song, or deeps whereof
But sacred silence tells.
To him his Country seemed
Even as a Mother, where
He rested—slept; and once he dreamed—
As on her bosom there—

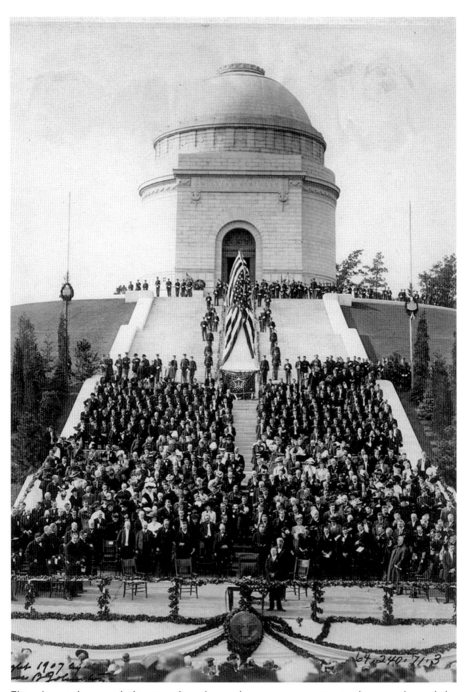

This photo taken on dedication day shows the monument prior to the unveiling of the bronze statue.

And thrilled to hear, within
That dream of her, the call
Of bugles and the clang and din
Of war... And o'er it all
His rapt eyes caught the bright
Old Banner, winging wild
And beck'ning him, as to the fight ...
When—even as a child--
He wakened—And the dream
Was real! And he leapt
As led the proud Flag through a gleam
Of tears the Mother wept.
His was a tender hand—
Even as a woman's is--
And yet as fixed, in Right's command,
As this bronze hand of his:
This was the Soldier brave—
This was the Victor fair—
This is the Hero Heaven gave
To glory here—and There.

The last speaker of the day was President Roosevelt, who commanded the attention of all those in attendance. He offered a retrospective of William McKinley's life and recalled pivotal moments that led them to that day, September 30, 1907. The first two paragraphs of his speech eloquently summed up the life of William McKinley:

We have gathered together today to pay our meed of respect and affection to the memory of William McKinley, who as President won a place in the hearts of the American people such as but three or four of all the Presidents of this country have ever won. He was of singular uprightness and purity of character, alike in public and in private life; a citizen who loved peace, he did his duty faithfully and well for four years of war when the honor of the Nation called him to arms. As Congressman, as governor of his State, and finally as President, he rose to the foremost place among our statesmen, reaching a position which would satisfy the keenest ambition; but he never lost that simple and thoughtful kindness toward every human being, great or small, lofty or humble, with whom he was brought in contact, which so endeared him to our people.

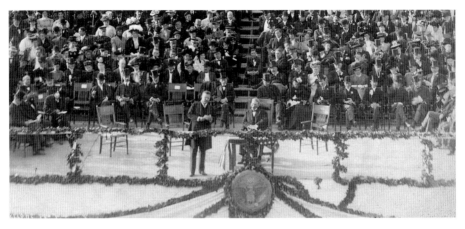

President Theodore Roosevelt makes his speech during the dedication ceremony on September 30, 1907.

> *He had to grapple with more serious and complex problems than any President since Lincoln, and yet, while meeting every demand of statesmanship, he continued to live a beautiful and touching family life, a life very healthy for this Nation to see in its foremost citizen; and now the woman who walked in the shadow ever after his death, the wife to whom his loss was a calamity more crushing than it could be to any other human being, lies beside him here in the same sepulcher.*

Unknown to the public on dedication day was that the body of President McKinley was not in the monument. According to the records of the Arnold Funeral Home, the McKinley National Memorial Association purchased two bronze caskets for President and Mrs. McKinley and two copper caskets for Katherine and baby Ida. The bodies of all four were transferred to these more permanent caskets before being moved to the monument on October 10, 1907.

Unfortunately, there were some very important people in McKinley's life who had passed on and were not able to celebrate the monument to William McKinley. Those who had died between 1901 and 1907 included association members Henry C. Payne, Eli S. Hannon, William A. Lynch, and close friend and former campaign manager Senator Marcus Hanna.

William McKinley's beloved wife Ida had visited her husband at the Werts Receiving Vault daily and surely would have seen the progress on the monument. Sadly, she passed away in May 1907, just a few short months before the completion of an incredible structure celebrating her husband's life.

<div align="right">6.</div>

The Last One Hundred Years

The work of the McKinley National Memorial Association did not stop once the dedication was over. They continued to meet regularly to discuss the needs of the site and maintenance issues. Within months of the dedication the association became aware of several concerns pertaining to the site. The foremost problem was the leaking of the dome, something that would constantly plague the monument.

When the monument was constructed there were no provisions made for sealing the joints of the granite blocks. Only cement was placed in the joints. The cement of the time was extremely porous. Soon water seeped through and leaks developed within the monument. Magonigle noticed problems with the dome when he visited the site in October 1908. His observations were noted in the November 21, 1908, *Transactions of the Board of Trustees The McKinley National Memorial Association*. The association consulted with Magonigle about a solution, and he recommended that oakum and melted lead be placed in a section of the dome as a type of caulking. The process was similar to how wooden ship decks were sealed. The oakum, made of loose hemp or jute fibers, was placed in the joints. Melted lead was poured on top making a waterproof seal. This proved successful on the test patch and monument superintendent Charles Anderson was charged with continuing the process on the entire dome.

A second concern that arose almost immediately was providing sufficient water to the Long Water to keep it full and cascading as designed. Initial solutions centered on tapping into the city of Canton's water system. This was eventually

deemed unfeasible, and instead a six-inch supply line was run from Mirror Lake in West Lawn Cemetery to the Long Water, solving the problem.

After the first cycle of seasons, it became clear that the effect of weather on the monument was greater than expected. During the hot and humid summer months, condensation formed on the cool interior stones and ran down the inside of the monument—literally raining inside! When the winter snows came, wind blew the elements into the monument. Magonigle's solution was fairly simple, and one for which he had planned. He recommended installing a large leather curtain to sliding tracks with hooks that were already in place. Churches and cathedrals in Europe successfully used similar devices to block the elements. To combat the condensation concerns a recommendation was made to install four registers in the floor and connect them to the gas heating system. Warming the interior prevented the formation of the condensation on the stones. The association approved both recommendations at their meeting on May 6, 1909.

As the 1920s approached, the association still battled the problem of water penetrating the dome. In September 1919, The Melbourne Bros. Co. of Canton, Ohio, received a contract to work on the problem. The following letter, a copy of which appears in the records of the association, demonstrates the quality of work they expected from all their contractors:

Sept. 22, 1919

The Melbourne Bros. Co.,
Canton, O.

Gentlemen:
The McKinley National Memorial Association accepts your proposal dated September 15, 1919 addressed to the Hon. William R. Day, the President of the Association, for repointing and recalking [sic] the exterior of the Mausoleum for $1678.00, subject to the following conditions:

> *It is understood that every joint on the exterior of the Mausoleum proper is to be examined and where the joints are calked [sic] with lead they shall be tightened; where the joints are cemented, if the cement is out, they shall be repointed and where the cement is loose they shall be raked out and repointed; all repointing is to be worked into the joints as deeply as possible and every joint, whether lead or cement, which is not already in first class shape shall be repaired as above so that when the work is completed every exterior joint of the Monument will be in first class shape and in as good condition as first class workmanship can make it.*

The cement pointing shall match the stone in color as near as possible and the work shall be done neatly so as not to stain the stonework. All refuse and debris is to be removed and the premises left in as good condition as when the work was started.

Work under this contract shall commence within a week from date hereof and shall proceed with all reasonable diligence until completed.

> The McKinley National Memorial Association
> BY (Signed) James K. Lynch
> Secretary

> Approved:
> September 22nd 1919.
> THE MELBOURNE BROTHERS COMPANY
> BY (Signed) W.E. Melbourne
> President.

During this same time period problems with the Long Water also arose. For several years prior to 1921 the Long Water had not functioned properly due to reduced water supply and problems with the cement bottom. Magonigle suggested at the annual meeting of the association on September 15, 1920, that the Long Water be filled in and converted to a flower garden. The association requested that Magonigle draw up plans and get estimates for the conversion. A year later during the annual meeting in Canton, Ohio, on September 21, 1921, the association decided that:

> *After consideration the Committee decided adversely for this plan for two reasons, first, because lagoons were considered more desirable, other things being equal, and secondly, because the making of flower beds would have cost as much as repairs to the Longwater and their keep would have been very high.*

Plans for the repair of the Long Water went forward and in July 1921, the association entered into a contract with The Kasch Roofing Company of Akron, Ohio, to repair the problems for $9,800.

A decade later, during the summer of 1930, The Albert Grauer Company replaced the skylight, which had fallen into disrepair and was leaking badly. The final cost was $912.

Throughout the years the association raised the funds that it needed to maintain the monument through contributions, investments, subscriptions to

The McKinley National Memorial Association Endowment Fund, and the sale of souvenirs, including books, medallions, watch fobs and granite chips.

As the years went on, maintaining the monument became a huge financial burden on the association. In 1939 Paul B. Belden, Chairman of the Building Committee, began negotiations with the Department of the Interior. The proposal allowed the Department of the Interior to take possession of the monument, make repairs, and then possession would return to the association to maintain from that point forward. The following resolution was made during the association's annual meeting on October 25, 1939.

> RESOLVED *by the Board of Trustees of The McKinley National Memorial Association that the action taken by the Executive Committee on May 19, 1939 be approved; that this Board of Trustees is in favor of entering into a cooperative agreement with the Department of the Interior under the Historic Sites Act of 1935; and that Paul B. Belden and James K. Lynch, President and Secretary respectively of the Association, be and they hereby are authorized and instructed in the name and for and on behalf of this Association to execute a cooperative agreement with the Department of the Interior, National Park Service under the Historic Sites Act of 1935 for the repair of the McKinley Memorial at Canton, Ohio, said agreement to be in such form and on such terms and conditions as said President and Secretary may in their judgment deem advisable and for the best interests of the Association and the Memorial.*

During the association's next annual meeting, on October 31, 1940, Secretary James K. Lynch reported that he and Paul B. Belden proposed the plan to the Advisory Board on National Parks, Historic Sites Building and Monuments on November 6, 1939, in Washington, D.C. The Advisory Board rejected their proposal, stating "that while it recognized the historical importance of the City of Canton, Ohio in its association with the life of William McKinley, twenty-fifth president of the United States, nevertheless that the memorial character of the City was similar to others in regard to the birth and death of other Presidents of the United States and that the number was so large that it was inadvisable for the National Park Service to assume the expense of repairs of such Monuments." Plainly put, the Department of the Interior did not want to set a precedent of this kind for fear that other cities would make the same request.

Lynch was not one to give up. He continued his fight until all avenues were exhausted. The last paragraph of his report describes the final efforts to have the federal government take control of the site.

On March 6, 1940 I had a special Bill introduced in the House of Representatives H.R. 8799, for authority to appropriate not exceeding $100,000 for the repair of the Monument by the National Park Service under the direction of the Secretary of the Interior. This Bill has not yet been called up for hearing in Committee and ever since the time that it might have come up in Committee the Congress has been so preoccupied with Rearmament and National Defense that I thought it was useless to try to press the matter under the present circumstances. I am hopeful that when the emergency is over and with the coming change of administration that relief may be obtained in this manner.

Relief did not come, however, and the McKinley National Memorial Association continued to maintain and operate the site until 1943 when the state of Ohio agreed to take over operation of the site. On October 20, 1943, the McKinley monument and its $135,000 endowment was transferred to The Ohio State Archaeological and Historical Society, now known as the Ohio Historical Society, under the following conditions:

Said Society shall hold and invest and reinvest said endowment fund and shall use the principal and income thereof for no other purposes than the restoration, maintenance, repair and administration of the Memorial and grounds and Long Water as a State Park with the right to consume the principal of said fund when necessary and on the express condition that said Society shall restore the Long Water to substantially its original design and condition, together with the installation of electric pumps to provide a supply of clear water and to re-circulate the water over the four cascades and shall recondition the Memorial grounds and landscaping and that all of said work shall be performed as soon as labor and materials are reasonably available and shall be completed within a reasonable time after the cessation of hostilities.

During the late 1940s the Ohio State Archaeological and Historical Society began to face some of the same problems the association had: the watertightness of the dome, including the stone joints, and high humidity within the monument. Additional problems included deteriorating stone walkways and steps and lack of access for the handicapped.

Problems persisted with the Long Water and early goals of restoring it and cleaning the millpond were postponed several times.

Ultimately the Ohio State Archaeological and Historical Society did complete rehabilitation of the monument and the grounds. The cost was approximately

$165,000, paid for by grants from the Ohio state legislature with support from then-Senator R.A. Pollock and then-Governor R.A. Lausche.

The final phase of the project began on August 1, 1951, when Garaux Bros. filled in the Long Water, something Magonigle had proposed decades earlier. The project was completed in time for a special ceremony observing the fiftieth anniversary of President McKinley's death on September 16, 1951.

After thirty years of state ownership the McKinley monument returned to private hands when the Stark County Historical Society, who today does business as the Wm. McKinley Presidential Library & Museum, received the title to the property in 1973. Ten years earlier the society had built a museum building adjacent to the monument. In 1975, the site was designated a National Historic Landmark.

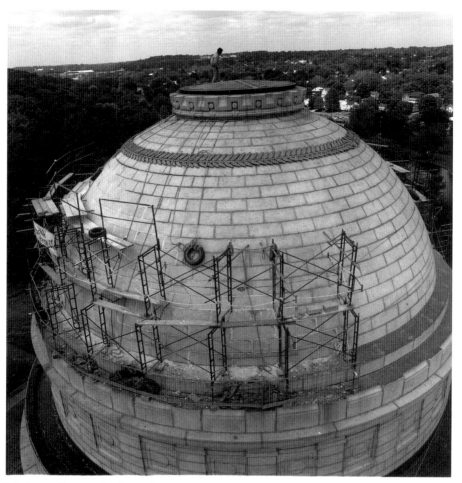

Work was done on the dome during a mainly cosmetic restoration project in 1976–1977.

As the United States celebrated its bicentennial in 1976, Canton and Stark County began a major bicentennial project called "The Restoration of McKinley Monument." The monetary goal of the Stark County Historical Society was $200,000 to rehabilitate the memorial and the grounds. The Timken Foundation was one of the first to step up to the task by giving a challenge grant of $75,000. The Quota Club of Canton and the Canton Jaycees organized and ran a campaign to match the Timken Foundation grant. In total, $215,000 was raised, and during 1976 and 1977, those funds were allocated to exterior and interior cleaning and caulking, heating and plumbing, roof repairs, electric wiring, repair of the bronze doors and statue, flagpoles, lighting, repair of the stained glass skylight, repair to the plaza and landscaping.

Although significant repairs were made in 1976 and 1977, most of it was cosmetic in nature, and problems still persisted with the dome. The society received additional grants from the Timken Foundation in 1981, 1983 and 1984 for further repairs. In 1985, a study identified a wide variety of structural defects. At this point the Stark County Historical Society turned to the federal government for assistance. Through the help of Congressman Ralph Regula, the society received four separate appropriations. The Department of the Interior and the National Park Service, under the Historic Sites Act of 1935, handled these funds. With these federal funds, along with generous support from the

A portion of the main staircase was removed to repair columns and stringers during the 1976-1977 project.

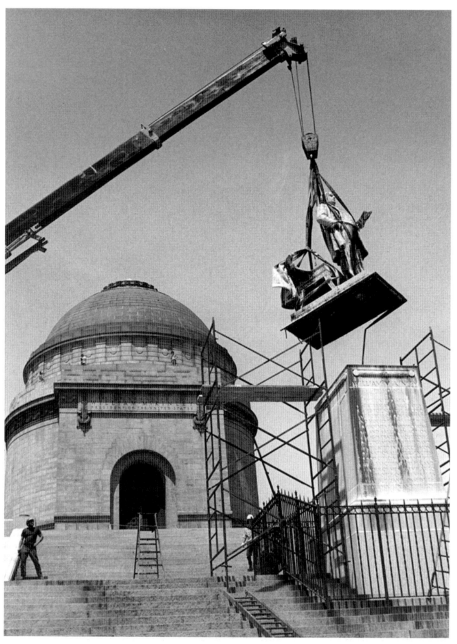

This image shows the statue being removed for restoration. Master bronze artist Eleftherics Karkadoulias, originally from Athens, Greece, restored it, along with the bronze doors. His foundry was located in Cincinnati, Ohio. Removal of the statue began on July 19, 1976.

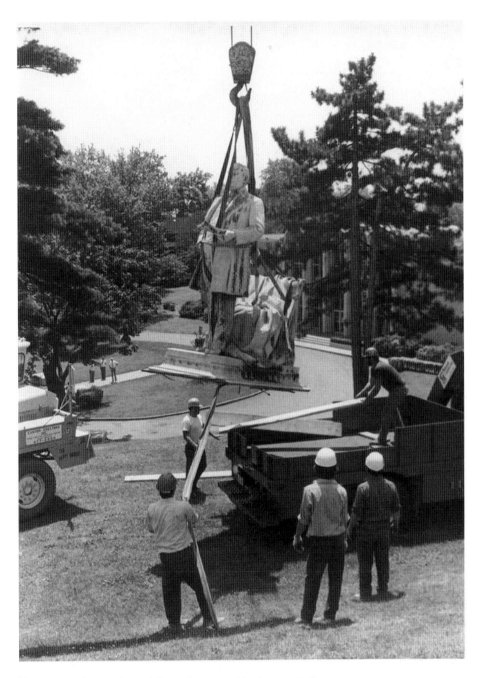

The statue is lowered carefully and prepared for transportation.

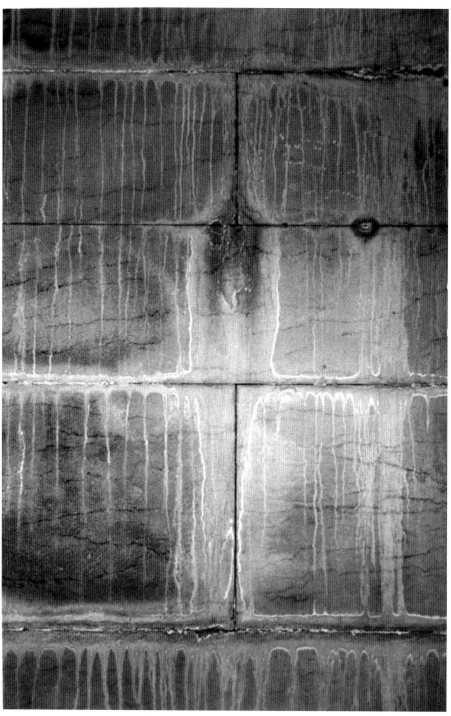

Years of water leaking through the dome and running down the interior walls caused staining of the marble.

Through the years the marble tiles in the entranceway became damaged. They were replaced during the restoration project of 1976-1977.

Timken, Hoover and Stark County Foundations, the Stark County Historical Society embarked on a multi-phase restoration and enhancement project.

Plans for the project began in 1985 with the assistance of the architectural firm of Geary, Moore and Ahrens, Inc. from Cleveland, Ohio. The staff of the society, under director Dr. Richard Werstler, and the Board of Trustees committee, headed by John Schubach, played a significant role throughout the project. Those that made up the restoration committee included Robert Belden, George Deal, John Dunning, James Ewing, Richard Schneider, William Sheffield, James Strawn, and Charles Zima, who volunteered as a project engineer.

The first phase of the project started in 1987 and focused almost exclusively on repair of the dome. Almost eighty years after it was built, waterproofing the dome was still a major problem. During this restoration project, however, innovations in materials allowed the problem to be completely solved. Most of the exterior dome stones were removed, treated with waterproof plaster and then reset. A caulking material supplied by DOW Chemical was then applied to all of the joints, almost three miles if they were laid end to end.

Phase two started in 1988 with the planning of many projects to be completed in 1989 under phase three. Among them was designing the

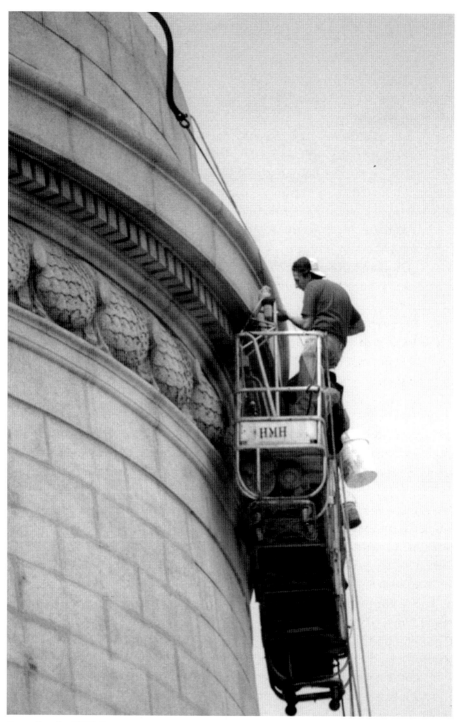

A worker for HMH Restoration performs repairs to the dome in 1987 as part of a multi-year restoration and enhancement of the monument and the grounds.

placement of the elevator that provides handicapped access to the monument. The elevator would be placed in a closet that had previously been used as the archives for the McKinley National Memorial Association. Outside, removing an existing window and installing a door provided access to the elevator from the plaza level. In this way, the design altered the appearance of the monument very little.

A vestibule with two glass doors was also installed at this time. The vestibule replaced one that had been installed in 1974. The construction of this element helped to control the humidity problems that had plagued the monument since its construction. It provided a barrier between the warm outside air and cool interior stone during the summer months, eliminating condensation from forming and running down the interior walls.

Enhancement to the grounds also began at this point, including the construction and improvement of the lower plaza, sidewalks and curbs. Also completed was the installation of the fountain by Schumacher Construction of Massillon.

As 1988 came to a close, planning began to replace the base of the bronze statue located in the middle of the main staircase. The original base of pink milford granite was cracked beyond repair and would be replaced by a base made from Kittledge Grey Barnetto Granite supplied by Toledo Cut Stone Company.

Many of the ground enhancement projects started in 1989 with phase three of the restoration. During this phase of construction, an access road to the rear of the monument, a parking lot and the installation of the elevator greatly improved access for handicapped visitors. The access roads were widened and landscaping work began with the removal of dead or diseased trees. Exterior and interior lighting, along with cameras, greatly improved the security of the site. Phase three also addressed structural issues with the main staircase. Most of the granite stair treads were removed and the pillars and stringers repaired. Inside the monument, the extremely outdated boiler was replaced with a new one, vastly improving the heating system. Phase three concluded with removal of the statue and replacement of the base.

The remaining phases of the project consisted mainly of continued enhancements to the grounds and improved signage on the site and throughout the community. One of the last major projects was the construction of the gazebo behind the monument, finished in the summer of 1992.

As the completion of the project drew near, a committee headed by Robert F. Belden began plans for a rededication ceremony on September 26, 1992. The activities corresponded with events that took place during the original dedication in 1907, including a parade, which had many units with either an historic or symbolic tie to President McKinley. The rededication of the monument marked

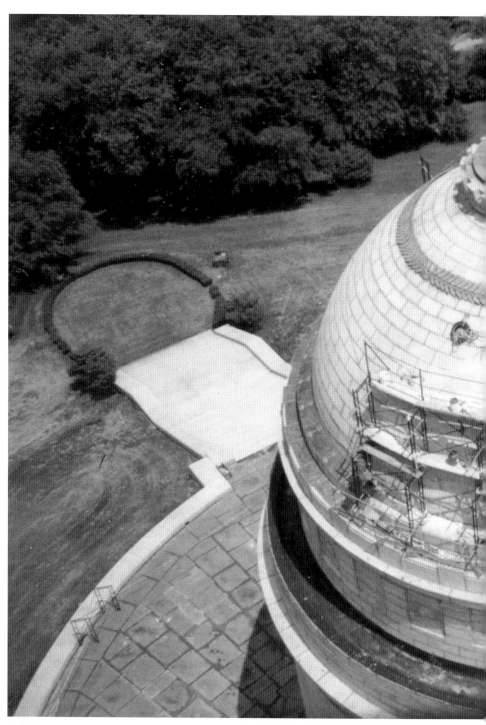

HMH Restoration removed many of the exterior stones on the dome. They were treated with waterproof plaster and then reset.

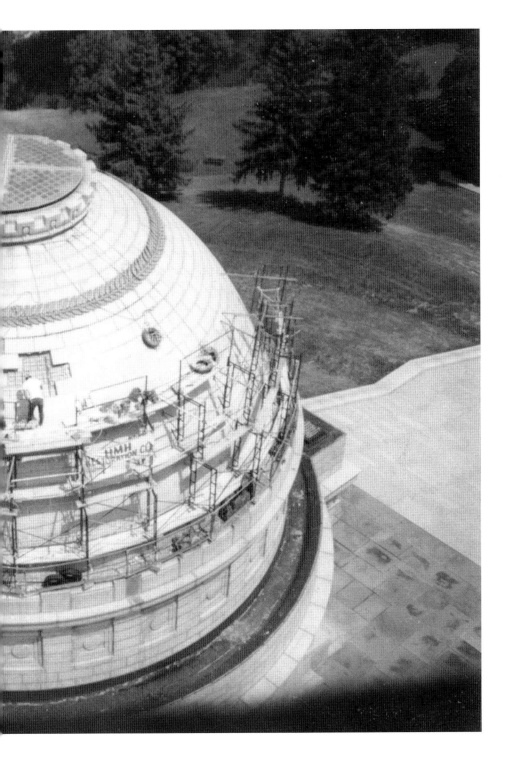

Structural problems with the main staircase were also addressed during the restoration project. This photo shows the deterioration of one of the support pillars under the steps.

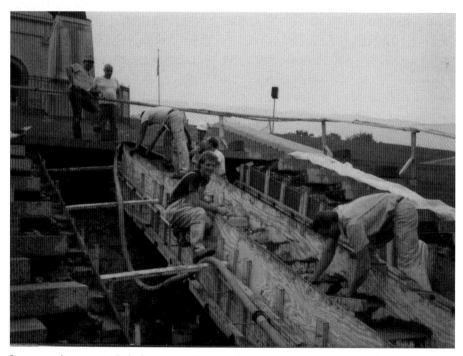

Repairing the steps included removing the granite treads, repairing the support structure and then replacing each step.

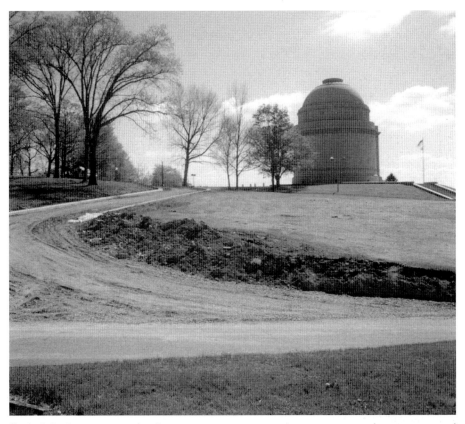

One of the largest ground enhancement projects was the construction of an access road to the rear of the monument. This road, along with the elevator that was installed, allowed handicapped guests to visit the monument.

an important cooperation between the federal government and the private community to honor the memory of our twenty-fifth president.

Today the Stark County Historical Society continues to own and operate the McKinley monument. The society still relies on donations and grants to maintain the high standards set forth by the McKinley National Memorial Association. In recent years the monument has undergone preventative maintenance. Under the guidance of museum director Joyce Yut and the architectural firm of Lawrence, Dykes, Goodenberger, Vandegrift & Clancy the interior plaster of the dome was repaired and repainted in 2001 by Guist Painting & Decorating of Canton, Ohio. That same year VIP Restoration of Cleveland, Ohio, made exterior dome repairs. In the summer of 2002, through a grant from the Save Outdoor Sculptures program, conservator Laurie Booth cleaned the bronze statue and coated it with a layer of protective wax. At the same time, through a grant from Save America's Treasures,

In this photo construction is being done on the gazebo at the rear of the monument. It was constructed during the summer of 1992 and was one of the last projects in the multi-year plan.

The dome is placed on the gazebo. This structure provides a shaded area for visitors and is a popular spot for small wedding ceremonies.

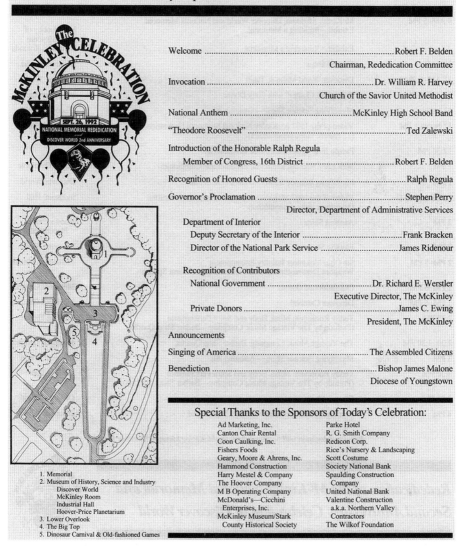

McKINLEY NATIONAL REDEDICATION CEREMONY
Saturday, September 26, 1992 1:00 PM

Welcome ..Robert F. Belden
Chairman, Rededication Committee

Invocation ..Dr. William R. Harvey
Church of the Savior United Methodist

National Anthem ..McKinley High School Band

"Theodore Roosevelt" ..Ted Zalewski

Introduction of the Honorable Ralph Regula
Member of Congress, 16th DistrictRobert F. Belden

Recognition of Honored Guests ...Ralph Regula

Governor's Proclamation ...Stephen Perry
Director, Department of Administrative Services
Department of Interior
Deputy Secretary of the Interior ...Frank Bracken
Director of the National Park ServiceJames Ridenour

Recognition of Contributors
National Government ...Dr. Richard E. Werstler
Executive Director, The McKinley
Private Donors ..James C. Ewing
President, The McKinley

Announcements

Singing of America ...The Assembled Citizens

Benediction ...Bishop James Malone
Diocese of Youngstown

Special Thanks to the Sponsors of Today's Celebration:

Ad Marketing, Inc.
Canton Chair Rental
Coon Caulking, Inc.
Fishers Foods
Geary, Moore & Ahrens, Inc.
Hammond Construction
Harry Mestel & Company
The Hoover Company
M B Operating Company
McDonald's—Cicchini
Enterprises, Inc.
McKinley Museum/Stark
County Historical Society

Parke Hotel
R. G. Smith Company
Redicon Corp.
Rice's Nursery & Landscaping
Scott Costume
Society National Bank
Spaulding Construction
Company
United National Bank
Valentine Construction
a.k.a. Northern Valley
Contractors
The Wilkof Foundation

1. Memorial
2. Museum of History, Science and Industry
 Discover World
 McKinley Room
 Industrial Hall
 Hoover-Price Planetarium
3. Lower Overlook
4. The Big Top
5. Dinosaur Carnival & Old-fashioned Games

This program illustrates the many activities that were planned for the rededication of the McKinley monument on September 26, 1992.

A protective wax coating is being applied to the bronze.

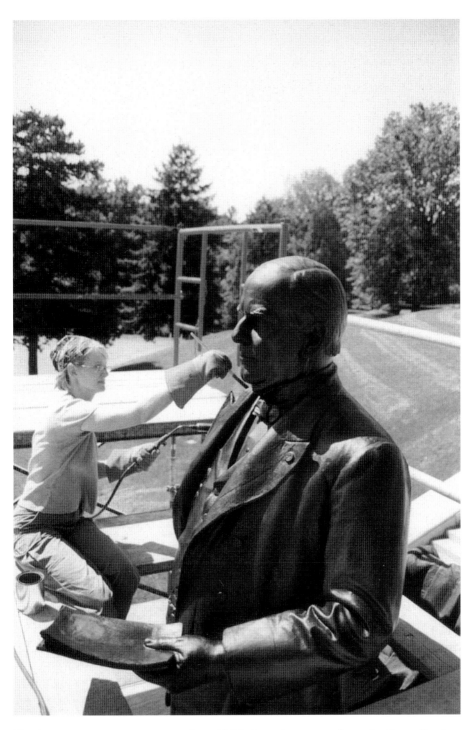

The bronze statue was conserved in 2002 through a grant from the Save Outdoor Sculptures program.

Each year thousands of people fill the grounds around the McKinley monument to celebrate the Fourth of July with music and fireworks.

Canton's Coon Restoration re-caulked the exterior dome. The exterior walls received attention from Keystone Waterproofing, Inc. of Greensburg, Pennsylvania. Using small electric grinding tools, all of the old tuck-pointing was removed, stones were repaired and then all the joints were sealed with new material.

Throughout the last one hundred years the monument has been visited by millions of people, both young and old, from all over the world. Couples have been married on the site and joggers have logged hundreds of miles running up and down the 108 steps. Each year thousands of school children come to the site to learn about our twenty-fifth president. The grounds surrounding the monument have been a gathering place for the people of Canton and Stark County since the beginning. The community gathers each year to celebrate the birth of our country, and sadly we have gathered on the site to remember those lost on September 11, 2001. The citizens of Canton, Stark County and the United States have supported the McKinley monument from the laying of the first stone one hundred years ago to today. Through that support, the memory of William, Ida, Katherine and baby Ida lives on for future generations. William McKinley would be proud.

Appendix A

A Chronological Outline of the Life of William McKinley

January 29, 1843	Born in Niles, Trumbull County, Ohio.
1849	Entered Public School in Niles.
1852	Moved to Poland, Mahoning County, Ohio.
1852	Entered the Union Seminary of Poland.
1858	Joined the Methodist Episcopal Church of Poland.
1860	Entered Allegheny College, Meadville, Pennsylvania.
1860	Left college because of illness; began teaching at Kerr District near Poland.
1861	Took job as assistant postmaster in the Poland post office.
June 11, 1861	Enlisted as a private in Company E of the Twenty-third Ohio Volunteer Infantry.
April 15, 1862	Promoted to regimental commissary sergeant.
September 24, 1862	Field commissioned second lieutenant on the Antietam Battlefield.
February 7, 1863	Promoted to first lieutenant.
July 25, 1864	Promoted to captain of Company G.
October 11, 1864	Participated in first presidential election while on march, voting for Abraham Lincoln.
March 13, 1865	Discharged from the army with the rank of brevet major.
1866	Entered the Albany School of Law.

1867	Graduated from Albany School of Law.
1867	Admitted to the Bar in Warren, Ohio.
March 23, 1867	Moved to Canton as a law partner of George W. Belden.
1868	Elected president of the Canton YMCA.
1869	Elected prosecuting attorney of Stark County.
January 25, 1871	Married Ida Saxton in First Presbyterian Church, Canton.
December 25, 1871	Daughter Katherine born.
April 1, 1873	Daughter Ida born.
August 22, 1873:	Daughter Ida died.
June 25, 1875	Daughter Katherine died.
1876	Elected representative to Congress.
1878, 1880 and 1882	Re-elected to Congress.
1884:	Election results of 1882 overturned by a special Democratic-controlled commission; seat awarded to his opponent, Jonathon H. Wallace.
1884, 1886 and 1888	Re-elected to Congress.
1890:	Defeated for Congress by John G. Warwick of Massillon.
November 3, 1891:	Elected governor of Ohio.
1892	Named presiding officer of Minneapolis Republican National Convention.
November 7, 1893	Re-elected governor of Ohio.
June 18, 1896	Nominated for president by Republican National Convention, St. Louis, Missouri.
November 3, 1896	Elected twenty-fifth president of the United States with Garret A. Hobart as vice president.
March 4, 1897:	Inaugurated president.
April 25–December 24, 1898	Oversaw United States victories in Spanish-American War.
November 21, 1899	Garret Hobart, vice president, died.
June 21, 1900	Re-nominated president in Philadelphia at the Republican National Convention.
November 6, 1900	Re-elected president with Theodore Roosevelt as vice president.
March 4, 1901	Second inauguration.
September 6, 1901	Shot by Leon Czolgosz at the Temple of Music at the Pan-American Exposition in Buffalo, New York.

September 14, 1901	Died at the home of Exposition director John G. Milburn, Buffalo, New York, at 2:15 a.m.
September 19, 1901	Interred in Werts Memorial Vault, West Lawn Cemetery, Canton, Ohio.
May 26, 1907	Mrs. McKinley died.
September 30, 1907	Dedication of McKinley National Memorial.
October 10, 1907	Bodies of President and Mrs. McKinley placed in the monument; the children, Katherine and Ida, removed from West Lawn Cemetery and placed in niches in the rear wall.

Source: Hartzell, Frederic S. *The Nation's Memorial To William McKinley*. Canton: The McKinley National Memorial, 1913.

Appendix B

Monumental Facts and Figures

The McKinley National Memorial Association was formed on September 26, 1901, and President Theodore Roosevelt named the first Board of Trustees.

In June 1903, contributions to the memorial fund reached $500,000.

Over sixty potential designs were submitted. The design chosen for the site combines a cross to represent a martyred president and a sword to represent McKinley's military service.

Construction began on June 6, 1905, with the removal of the first shovelful of soil.

The foundation walls are made of over two million bricks. They are set fifteen feet deep on a double-ring wall of concrete.

The laying of the cornerstone took place on November 16, 1905, with Mrs. McKinley and other family members in attendance.

The exterior stone is pink milford granite from Massachusetts. The interior is marble from Tennessee.

The monument is ninety-six feet tall and seventy-nine feet in diameter at the base.

More than 35,000 cubic yards of soil were moved to create the four terraces of the main staircase.

There are 108 steps. Each one is fifty feet wide.

The area called the Long Water is 575 feet long.

The original landscaping consisted of 42 full-sized maple and elm trees, 350 large sugar maples and 1,200 plants.

The base and bronze statue of President McKinley, located on the main staircase, towers twenty-three feet above the ground.

The skylight at the top of the dome measures twelve feet in diameter.

Dedication of the monument took place on September 30, 1907.

The Stark County Historical Society, a private non-profit organization that relies on donations and grants to operate and maintain the site, now owns the monument.

Bibliography

Arnold's Funeral Home. Funeral Records Book 1.

"Commonwealth of Australia Design for the Lay-Out of the Federal Capital City." Typescript in Australian Archives, ACT, Series A762 FC36, [1912].

Hartzell, Frederic S. *The Nation's Memorial To William McKinley*. Canton: The McKinley National Memorial, 1913.

Heald, Edward T. *William McKinley: A Condensed Biography*. Canton: The Stark County Historical Society, 1964.

————. *The Stark County Story*. Vol. 2, *The McKinley Era 1875–1901*. Canton: The Stark County Historical Society, 1950.

Judge 41, no. 1051 (December 7, 1901). New York: Sackett & Wilhelms Litho & Prg Co.

Kenney, Kimberly A. *Canton: A Journey Through Time*. Charleston: Arcadia Publishing, 2003.

Lehman, John. *A Standard History of Stark County, Ohio*. Chicago: The Lewis Publishing Company, 1916.

Madway, Ruthanne. "The Classical Tradition and the Modern Memorial: The Work of H. Van Buren Magonigle." Qualifying Paper, Department of Fine Arts, Harvard University, 1990.

Magonigle, Harold Van Buren. Papers. Archives and Manuscript Division, New York Public Library, New York City.

McElroy, Richard L. *William McKinley and Our America*. Canton: Stark County Historical Society, 1996.

The McKinley National Memorial Association. *The Transactions of the Board of Trustees*, Vol. 1, 1901-1905.

———. *The Transactions of the Board of Trustees*, Vol. 2. 1906–1912.

———. *The Transactions of the Board of Trustees*, Vol. 3, 1912–1916.

———. *The Transactions of the Board of Trustees*, Vol. 4, 1916–1926.

———. *The Transactions of the Board of Trustees*, Vol. 5, 1927–1937.

———. *The Transactions of the Board of Trustees*, Vol. 6, 1938–1943.

Stark County Historical Society. *The McKinley National Memorial*. Canton: Stark County Historical Society, 1992.

———. *Quarterly Bulletin No. 16*. Canton: Stark County Historical Society, July 1951.

Index